Children's First Art Academy

Two-year-old Art Curriculum and Activities

Author: Katherine Karayiannis

Artwork & photography by Katherine Karayiannis

Published by Children's First Art Academy LLC

Copyright 2020

Edition 1

Publication date: 2020

All rights reserved. No part of this publication may be reproduced, stored in a retrieval system or transmitted in any way or by any means, electronic, mechanical, photocopying, recording or otherwise without the prior written permission of the copyright holder.

This book has been written as a tool for instructional and recreational use. The reader takes full responsibility for the use of this book and the information within at his own discretion and risk. The author and publisher cannot take responsibility for injuries, losses or any damages resulting from the use of this book.

Permission to photograph Maximus Atkinson and use his photos in this book granted by Emily Crooks, mother.

Like us on Facebook: Children's First Art Academy LLC

Instagram: #thepreschoolartexpert

I'm Katherine Karayiannis. I have been working with children since I was ten when I volunteered in my father's childcare center. This gave me hands-on experience with infants through school-agers!

Later, I attended Western Kentucky University where I graduated Magna Cum Laude with a Bachelor's degree in Art Education.

Since graduation, I have taught art in the public schools and at the vocational school, taught in the Autism Unit, worked as a Nanny, taught private art lessons, taught preschool and taught art to preschoolers! I have over thirty years of experience working with preschoolers! Preschool is my favorite age to teach!

Because I saw a need for curriculum in the preschool area, I decided to write this book.

This book is written with parents and children in mind as a home-based curriculum and activities book. It is for the preschool teacher as a school curriculum or addition to your school curriculum. It is for those who are homeschooling. It is for every socio-economic group and every Ethnicity. It is for mainstream children as well as those with special needs, as art speaks to everyone. It is a valuable tool for children to get an introduction to and a foundation in art to prepare for the world ahead.

It is written in a simple way so that parents, and teachers alike, with or without an art background, can easily teach art skills to their children and students.

I have used many of these projects with children in and outside the classroom. Some are my own ideas, some I borrowed from other teachers and some were found on Pinterest.

I hope you enjoy what follows and spend many hours learning with your children!

Katherine

Dedication Page

This book is dedicated to all the children I have ever taught and observed. Thank you for giving me firsthand knowledge of what you need to learn to be successful in the ART room!

Katherine

Table of Contents

	Introduction	1-2
Unit 1:	Shapes & Primary colors	3-13
Unit 2:	Shapes & Secondary colors	14-24
Unit: 3	Mixing Secondary colors	25-35
Unit: 4	Painting with fingers and hands (and other objects)	36-46
Unit: 5	Painting with the brush	47-56
Unit: 6	Drawing Crayons Sidewalk chalk markers	57-65
Unit: 7	All American activities	66-75
Unit: 8	Mixed-up miscellaneous	76-85
Unit: 9	Printmaking	86-103
Unit: 10	Collage	104-128

Introduction:
Two-year-old Curriculum and Activities

The two-year-old curriculum and activities book is an introduction to art. It was written for parents, preschool teachers, homeschoolers and anyone who wants an art education for their two-year-old. It focuses on basic skills. Throughout the book, each unit will cover an introduction to various art skills, techniques and vocabulary. The two-year-old curriculum and activities book establishes the parent/ teacher as the teacher and facilitator, preparer of projects and partner in learning through experimentation and play.

As you go through the Two-year-old book you will be doing most of the work since, at this age, children's skills are limited. Each successive book gives your child more responsibility as his or her art skills increase. As you and your child explore each activity, you will become partners in experimentation and discovery. As you interact, you will use your imaginations to implement suggestions for each activity, while coming up with your own unique additions that fit your learning goals and abilities.

While this book is meant to be used to teach and learn art, each child is different and will progress at his or her own pace. Some children will be advanced beyond the recommended age while others, with no art background, may be at the introductory level. Activities can be followed in the given sequence or mixed or skipped. As you use patience with your child to build confidence, he or she will develop skills while having fun! Give your child credit for every effort, as each piece he or she creates is beautiful! Remember – It doesn't have to be perfect!

I have written this book to be developmentally, age appropriate. Each unit teaches vocabulary words, addresses different learning styles, shows links to how projects relate to other subjects and has an accompanying activity, book or artist. Learning is meant to occur through exploration, experimentation and play as you and your child manipulate materials. Repeating vocabulary and activities while using a variety of techniques will reinforce learning.

There are two books that will follow the two-year-old curriculum: The Three-year-old curriculum and activities book and The Four-year-old curriculum and activities book. Once you have worked through the Two-year-old curriculum and activities book, be sure to look for the others in the series.

This book is a wonderful way for you and your child to share interactive time together!

How to use this book:

Each Unit will include the following:

- Unit Introduction and description.

- List of vocabulary words corresponding with the activities in the unit. You can practice these words with your child.

- Learning styles and senses children will use during the lesson.

- Learning Links which are ways the lessons link to other subjects.

- An accompanying activity that will reinforce learning and make a real-world connection. (*See the bottom of each page*).

Most of all, remember to have fun!

Two-year-old curriculum

UNIT #1

Two-year-old curriculum

Unit One Introduction and explanation:

Unit one of the Two-year-old curriculum and activity book focuses on basic skills. The unit covers the basic geometric shapes circle, square and triangle. The unit covers the Primary colors red, blue and yellow. Throughout the unit, children are introduced to how to make the shapes circle, square and triangle and to recognize the Primary colors red, blue and yellow through song. Singing helps children remember information with rhythm. Children love to sing and create! You will probably find them asking to do these unit activities over and over.

As you play through this unit with your child, encourage him/ her to repeat the vocabulary words as you talk about each activity.

Vocabulary:
Red	Circle
Blue	Square
Yellow	Triangle

Learning styles addressed:
Visual
Auditory
Kinesthetic

Learning Links:
Art- colors: red, blue, yellow

Geometry- shapes: circle, square, triangle

Language arts / phonics: sound R, rhyme

Music: singing and rhythm

Two-year-old Curriculum

Unit #1: Shapes and Primary colors
January: Activity #1 – Hand paint a red circle

FOCUS:
Color: red
Shape: circle
Letter: R

MATERIALS:
large white sheet of paper
paper plate
pencil
Red non-toxic paint
wipes

Instructions:

1. Lay out the white sheet of paper.
2. Use the pencil to draw a circle on the white sheet of paper.
3. Pour some red paint onto the paper plate.
4. Dip your child's hands into the red paint.
5. While singing to the tune of "wheels on the Bus", sing these lyrics:
 "My little red hands go round and round, round and round, round and round. My little red hands go round and round. Look now I've made a circle."
6. While singing, gently assist the child's hands to go around the inside shape of the drawn circle and fill in the whole circle with red.
7. Encourage your child to sing along!
8. When you are finished painting, use the wipes to get the paint off your child's hands.

Accompanying activity: *January activity #1*
Identify colors and shapes in the environment.

Accompanying video: *January activity #1*
Youtube Video: The Kandinsky Effect.

Two-year-old Curriculum

Unit #1: Shapes and Primary colors
January: Activity #2 – Hand paint a blue circle

FOCUS:
Color: blue
Shape: circle
Letter: B

MATERIALS:
large white sheet of paper
paper plate
pencil
blue non-toxic paint
wipes

Instructions:

1. Lay out the white sheet of paper.
2. Draw a circle on the white sheet of paper.
3. Pour some blue paint onto the paper plate.
4. Dip your child's hands into the blue paint.
5. While singing to the tune of "wheels on the Bus", sing these lyrics:
 "My bouncy blue hands go round and round, round and round, round and round. My bouncy blue hands go round and round. Look now I've made a circle."
6. While singing, gently assist the child's hands to go around the inside shape of the drawn circle and fill in the whole circle with blue.
7. Encourage your child to sing along!
8. When you are finished painting, use the wipes to get the paint off your child's hands.

Accompanying activity: *January activity #2*
Identify colors and shapes in the environment.

Accompanying video: *January activity #2*
Youtube Video: The Kandinsky Effect.

Two-year-old Curriculum

Unit #1: Shapes and Primary colors
January: Activity #3 – Hand paint a yellow circle

FOCUS:
Color: yellow
Shape: circle
Letter: Y

MATERIALS:
large white sheet of paper
paper plate
Pencil
Yellow non-toxic paint
wipes

Instructions:

1. Lay out the white sheet of paper.
1. Using the pencil, draw a circle on the white sheet of paper.
2. Pour some yellow paint onto the paper plate.
3. Dip your child's hands into the yellow paint.
4. While singing to the tune of "wheels on the Bus", sing these lyrics:
 "My young yellow hands go round and round, round and round, round and round. My young yellow hands go round and round. Look now I've made a circle."
5. While singing, gently assist the child's hands to go around the inside shape of the drawn circle and fill in the whole circle with yellow.
6. Encourage your child to sing along!
7. When you are finished painting, use the wipes to get the paint off your child's hands.

Accompanying activity: *January activity #3*
Identify colors and shapes in the environment.

Accompanying video: *January activity #3*
Youtube Video: The Kandinsky Effect.

Two-year-old Curriculum

Unit #1: Shapes and Primary colors
January: Activity #4 – Hand paint a red square

FOCUS:
Color: red
Shape: square

MATERIALS:
large white sheet of paper
paper plate
Pencil
red non-toxic paint
wipes

Instructions:

1. Lay out the white sheet of paper.
2. Using the pencil, draw a square on the white sheet of paper.
3. Pour some red paint onto the paper plate.
4. Dip your child's hands into the red paint.
5. Recite this simple rhyme:
 "Square, square, I see you there. Four sides, four corners make a square."
6. While reciting the rhyme, gently move your child's hands around the square to fill it in with the red paint.
7. Encourage your child to sing along!
8. When you are finished painting, use the wipes to get the paint off your child's hands.

Accompanying activity: *January activity #4*
Identify colors and shapes in the environment.

Accompanying video: *January activity #4*
Youtube Video: Mondrian Animation
Mondrian Animation is a video that is representative of Mondrian's style. It shows many squares and rectangles so, as you and your child watch it, you can easily identify the shapes.

Two-year-old Curriculum

Unit #1: Shapes and Primary colors
January: Activity #5 – Hand paint a blue square

FOCUS:
Color: blue
Shape: square

MATERIALS:
large white sheet of paper
paper plate
pencil
blue non-toxic paint
wipes

Instructions:

1. Lay out the white sheet of paper.
2. Using the pencil, draw a square on the white sheet of paper.
3. Pour some blue paint onto the paper plate.
4. Dip your child's hands into the blue paint.
5. Recite this simple rhyme:
 "Square, square, I see you there. Four sides, four corners make a square."
6. While reciting the rhyme, gently move your child's hands around the square to fill it in with blue.
7. Encourage your child to sing along!
8. When you are finished painting, use the wipes to get the paint off your child's hands.

Accompanying activity: *January activity #4*
Identify colors and shapes in the environment.

Accompanying video: *January activity #5*
Youtube Video: Mondrian Animation
Mondrian Animation is a video that is representative of Mondrian's style. It shows many squares and rectangles so, as you and your child watch it, you can easily identify the shapes.

Two-year-old Curriculum

Unit #1: Shapes and Primary colors
January: Activity #6 – Hand paint a yellow square

FOCUS:
Color: yellow
Shape: square

MATERIALS:
large white sheet of paper
paper plate
Pencil
yellow non-toxic paint
wipes

Instructions:

1. Lay out the white sheet of paper.
2. Draw a square on the white sheet of paper.
3. Pour some yellow paint onto the paper plate.
4. Dip your child's hands into the yellow paint.
5. Recite this simple rhyme:
 "Square, square, I see you there. Four sides, four corners make a square."
6. While reciting the rhyme, gently move your child's hands around the square to fill it in with yellow.
7. When you are finished painting, use the wipes to get the paint off your child's hands.

Accompanying activity: *January activity #4*
Identify colors and shapes in the environment.

Accompanying video: *January activity #6*
Youtube Video: Mondrian Animation
Mondrian Animation is a video that is representative of Mondrian's style. It shows many squares and rectangles so, as you and your child watch it, you can easily identify the shapes.

Two-year-old Curriculum

Unit #1: Shapes and Primary colors
January: Activity #7 – Hand paint a red triangle

FOCUS:
Color: red
Shape: triangle

MATERIALS:
large white sheet of paper
paper plate
Pencil
red non-toxic paint
wipes

Instructions:

1. Lay out the white sheet of paper.
2. Draw a triangle on the white sheet of paper.
3. Pour some red paint onto the paper plate.
4. Dip your child's hands into the red paint.
5. Recite this simple rhyme:
 "I see a triangle happy as can be. Corners you have them, 1,2,3."
6. While reciting the rhyme, gently move your child's hands around the triangle to fill it in with red.
7. When you are finished painting, use the wipes to get the paint off your child's hands.

Accompanying activity: *January activity #7*
Identify colors and shapes in the environment.

Accompanying reading: *January activity #7*
The tiny Traveler, Egypt: A book of shapes

Two-year-old Curriculum

Unit #1: Shapes and Primary colors
January: Activity #8 – Hand paint a blue triangle

FOCUS:
Color: blue
Shape: triangle

MATERIALS:
large white sheet of paper
paper plate
Pencil
blue non-toxic paint
wipes

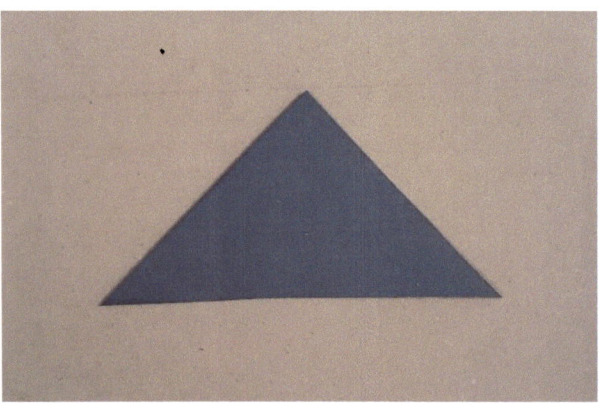

Instructions:

1. Lay out the white sheet of paper.
2. Draw a triangle on the white sheet of paper.
3. Pour some blue paint onto the paper plate.
4. Dip your child's hands into the blue paint.
5. Recite this simple rhyme:
 "I see a triangle happy as can be. Corners you have them, 1,2,3."
6. While reciting the rhyme, gently move your child's hands around the triangle to fill it in with blue.
7. When you are finished painting, use the wipes to get the paint off your child's hands.

Accompanying activity: *January activity #8*
Identify colors and shapes in the environment.

Accompanying reading: *January activity #8*
The tiny Traveler, Egypt: A book of shapes

Two-year-old Curriculum

Unit #1: Shapes and Primary colors
February: Activity #1 – Hand paint a yellow triangle

FOCUS:
Color: yellow
Shape: triangle

MATERIALS:
large white sheet of paper
paper plate
Pencil
yellow non-toxic paint
wipes

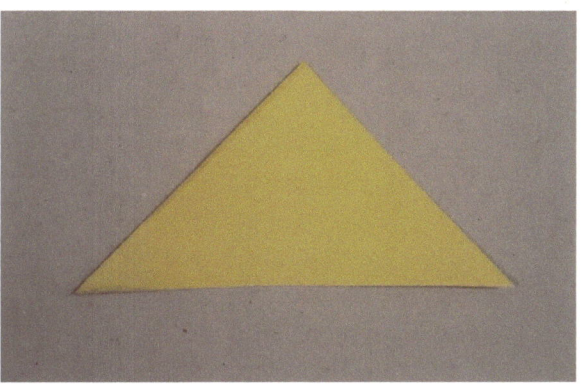

Instructions:

1. Lay out the white sheet of paper.
2. Draw a triangle on the white sheet of paper.
3. Pour some yellow paint onto the paper plate.
4. Dip your child's hands into the yellow paint.
5. Recite this simple rhyme:
 "I see a triangle happy as can be. Corners you have them, 1,2,3."
6. While reciting the rhyme, gently move your child's hands around the triangle to fill it in with yellow.
7. When you are finished painting, use the wipes to get the paint off your child's hands.

Accompanying activity: *February activity #1*
Identify colors and shapes in the environment.

Accompanying reading: *February activity #1*
The tiny Traveler, Egypt: A book of shapes

Two-year-old curriculum

UNIT #2

Unit Two Introduction and explanation:

Unit two of The Two-year-old curriculum and activity book focuses on basic skills. The unit covers the shapes oval, rectangle and star. The unit covers the Secondary colors green, orange and purple. Throughout the unit, children are introduced to how to make the shapes oval, rectangle and star and to recognize the Secondary colors green, orange and purple through song and repetition. You will probably find your child asking to do these unit activities over and over.

As you play through this unit with your child, encourage him/ her to repeat the vocabulary words as you talk about each activity.

Vocabulary:
Green	Oval
Orange	Rectangle
Purple	Star

Learning styles addressed:
Visual
Auditory
Kinesthetic

Learning Links:
Art- colors: green, orange, purple

Geometry- shapes: oval, rectangle, star

Music: singing and rhythm

Two-year-old Curriculum

Unit #2: Shapes and Secondary colors
February: Activity #2 – Hand paint a green oval

FOCUS:
Color: green
Shape: oval

MATERIALS:
large white sheet of paper
paper plate
Pencil
green non-toxic paint
wipes

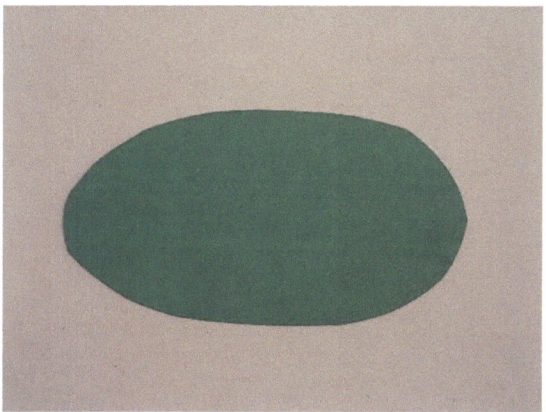

Instructions:

1. Lay out the white sheet of paper.
2. Draw an oval on the white sheet of paper.
3. Pour some green paint onto the paper plate.
4. Dip your child's hands into the green paint.
5. Say "this is an oval. It looks like an egg."
 While telling your child about the oval shape, gently move your child's hands around the oval to fill it in with green.
6. When you are finished painting, use the wipes to get the paint off your child's hands.

Accompanying activity: *February activity #2*
Identify colors and shapes in the environment.

Accompanying activity: *February activity #2*
What can you find that is an oval shape? Eggs.

Two-year-old Curriculum

Unit #2: Shapes and Secondary colors
February: Activity #3 – Hand paint an orange oval

FOCUS:
Color: orange
Shape: oval

MATERIALS:
large white sheet of paper
paper plate
Pencil
orange non-toxic paint
wipes

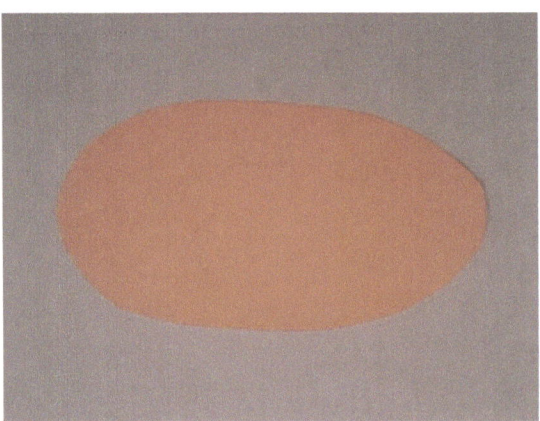

Instructions:

1. Lay out the white sheet of paper.
2. Draw an oval on the white sheet of paper.
3. Pour some orange paint onto the paper plate.
4. Dip your child's hands into the orange paint.
5. Again say, "This is an oval. It looks like an egg."
6. While telling your child about the oval shape, gently move your child's hands around the oval to fill it in with orange.
7. When you are finished painting, use the wipes to get the paint off your child's hands.

Accompanying activity: *February activity #3*
Identify colors and shapes in the environment.

Accompanying activity: *February activity #3*
What can you find that is an oval shape? Eggs.

Two-year-old Curriculum

Unit #2: Shapes and Secondary colors
February: Activity #4 – Hand paint a purple oval

FOCUS:
Color: purple
Shape: oval

MATERIALS:
large white sheet of paper
paper plate
pencil
purple non-toxic paint
wipes

Instructions:

1. Lay out the white sheet of paper.
2. Draw an oval on the white sheet of paper.
3. Pour some purple paint onto the paper plate.
4. Dip your child's hands into the purple paint.
5. Again say, "This is an oval. It looks like an egg."
6. While telling your child about the oval shape, gently move your child's hands around the oval to fill it in with purple.
7. When you are finished painting, use the wipes to get the paint off your child's hands.

Accompanying activity: *February activity #4*
Identify colors and shapes in the environment.

Accompanying activity: *February activity #4*
What can you find that is an oval shape? Eggs.

Two-year-old Curriculum

Unit #2: Shapes and Secondary colors
February: Activity #5 – Hand paint a green rectangle

FOCUS:
Color: green
Shape: rectangle

MATERIALS:
large white sheet of paper
paper plate
pencil
green non-toxic paint
wipes

Instructions:

1. Lay out the white sheet of paper.
2. Draw a rectangle on the white sheet of paper.
3. Pour some green paint onto the paper plate.
4. Dip your child's hands into the green paint.
5. While telling your child about the rectangle, gently move your child's hands around the rectangle to fill it in with green.
6. As you are painting, you can say, "Rectangle, rectangle, I see a rectangle".
7. Saying the name of the shape as you are painting will reinforce your child's learning.
8. When you are finished painting, use the wipes to get the paint off your child's hands.

Accompanying activity: *February activity #5*
Identify colors and shapes in the environment.

Accompanying activity: *February activity #5*
What can you find that is a rectangle shape? The door.

Two-year-old Curriculum

Unit #2: Shapes and Secondary colors
February: Activity #6 – Hand paint an orange rectangle

FOCUS:
Color: orange
Shape: rectangle

MATERIALS:
large white sheet of paper
paper plate
pencil
orange non-toxic paint
wipes

Instructions:

1. Lay out the white sheet of paper.
2. Draw a rectangle on the white sheet of paper.
3. Pour some orange paint onto the paper plate.
4. Dip your child's hands into the orange paint.
5. While telling your child about the rectangle, gently move your child's hands around the rectangle to fill it in with orange.
6. As you are painting, you can say, "Rectangle, rectangle, I see a rectangle".
7. Saying the name of the shape as you are painting will reinforce your child's learning.
8. When you are finished painting, use the wipes to get the paint off your child's hands.

Accompanying activity: *February activity #6*
Identify colors and shapes in the environment.

Accompanying activity: *February activity #6*
What can you find that is a rectangle shape? The door.

Two-year-old Curriculum

Unit #2: Shapes and Secondary colors
February: Activity #7 – Hand paint a purple rectangle

FOCUS:
Color: purple
Shape: rectangle

MATERIALS:
large white sheet of paper
paper plate
pencil
purple non-toxic paint
wipes

Instructions:

1. Lay out the white sheet of paper.
2. Draw a rectangle on the white sheet of paper.
3. Pour some purple paint onto the paper plate.
4. Dip your child's hands into the purple paint.
5. While telling your child about the rectangle, gently move your child's hands around the rectangle to fill it in with purple.
6. As you are painting, you can say, "Rectangle, rectangle, I see a rectangle".
7. Saying the name of the shape as you are painting will reinforce your child's learning.
8. When you are finished painting, use the wipes to get the paint off your child's hands.

Accompanying activity: *February activity #7*
Identify colors and shapes in the environment.

Accompanying activity: *February activity #7*
What can you find that is a rectangle shape? The door.

Two-year-old Curriculum

Unit #2: Shapes and Secondary colors
February: Activity #8 – Hand paint a green star

FOCUS:
Color: green
Shape: star

MATERIALS:
large white sheet of paper
paper plate
pencil
green non-toxic paint
wipes

Instructions:

1. Lay out the white sheet of paper.
2. Draw a star on the white sheet of paper.
3. Pour some green paint onto the paper plate.
4. Dip your child's hands into the green paint.
5. Explain to your child that you are going to paint the star green while showing him/ her the green paint.
6. Recite this simple rhyme:
 "Star, star, I see you from afar. I look up and there you are."
7. While reciting the rhyme, gently move your child's hands around the star to fill it in with green.

Accompanying activity: *February activity #8*
Identify colors and shapes in the environment.

Accompanying activity: *February activity #8*
Look up at the night sky and see if you can find any stars.

Two-year-old Curriculum

Unit #2: Shapes and Secondary colors
February: Activity #9 – Hand painting an orange star

FOCUS:
Color: orange
Shape: star

MATERIALS:
large white sheet of paper
paper plate
pencil
orange non-toxic paint
wipes

Instructions:

1. Lay out the white sheet of paper.
2. Draw a star on the white sheet of paper.
3. Pour some orange paint onto the paper plate.
4. Dip your child's hands into the orange paint.
5. Explain to your child that you are going to paint the star orange while showing them the orange paint.
6. Recite this simple rhyme:
 "Star, star, I see you from afar. I look up and there you are."
7. While reciting the rhyme, gently move your child's hands around the star to fill it in with orange.

Accompanying activity: *February activity #9*
Identify colors and shapes in the environment.

Accompanying activity: *February activity #9*
Look up at the night sky and see if you can find any stars.

Two-year-old Curriculum

Unit #2: Shapes and Secondary colors
March: Activity #1 – Hand painting a purple star

FOCUS:
Color: purple
Shape: star

MATERIALS:
large white sheet of paper
paper plate
pencil
purple non-toxic paint
wipes

Instructions:

1. Lay out the white sheet of paper.
2. Draw a star on the white sheet of paper.
3. Pour some purple paint onto the paper plate.
4. Dip your child's hands into the purple paint.
5. Explain to your child that you are going to paint the star purple while showing him or her the purple paint.
6. Recite this simple rhyme:
 "Star, star, I see you from afar. I look up and there you are.
7. While reciting the rhyme, gently move your child's hands around the star to fill it in with purple.

Accompanying activity: *March activity #1*
Identify colors and shapes in the environment.

Accompanying activity: *March activity #1*
Look up at the night sky and see if you can find any stars.

UNIT #3

Two-year-old curriculum

Unit Three Introduction and explanation:

Unit three of The Two-year-old curriculum and activity book continues to focus on basic skills. The unit covers the Secondary colors green, orange and purple. Throughout the unit children will have fun and get messy mixing the Secondary colors green, orange and purple as they practice identifying each color. They will also be mixing colors to create creatures in their environment as they learn to identify some of the creatures of Spring.

As you play through this unit with your child, encourage him/ her to repeat the vocabulary words as you talk about each activity.

Unit Three vocabulary:
Green butterfly
Orange beetle
Purple grasshopper
glacier

Learning styles addressed:
Visual
Kinesthetic

Learning Links:
Art- colors: green, orange, purple
 texture: the feel of the shaving cream

Science – plants: grass, flowers
 environment: sun, glacier
 insects: butterfly, beetle, grasshopper

Two-year-old Curriculum

Unit #3: Mixing Secondary colors
March: Activity #2 – Mixing Primary colors to make green

FOCUS:
Mixing the Primary
colors yellow and blue
to make green

MATERIALS:
yellow non-toxic paint
blue non-toxic paint
shaving cream
plastic sheet to cover table

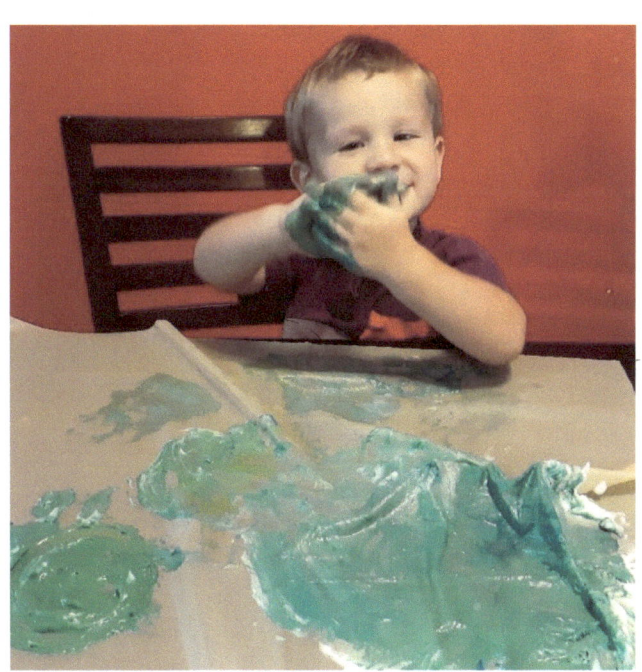

Instructions:

1. lay out the plastic sheet on the table.
2. spray two piles of shaving cream onto the table.
3. add drops of yellow paint to one pile.
4. add drops of blue paint to the other pile.
5. Allow your child to mix and blend the two piles of shaving cream together until it turns green.

Accompanying activity: *March #2*
Take a walk outside and identify things that are green.

Two-year-old Curriculum

Unit #3: Mixing Secondary colors
March: Activity #3 – Mixing Primary colors to make orange

FOCUS:
Mixing the Primary colors
red and yellow to make orange

MATERIALS:
red non-toxic paint
yellow non-toxic paint
shaving cream
plastic sheet to cover table

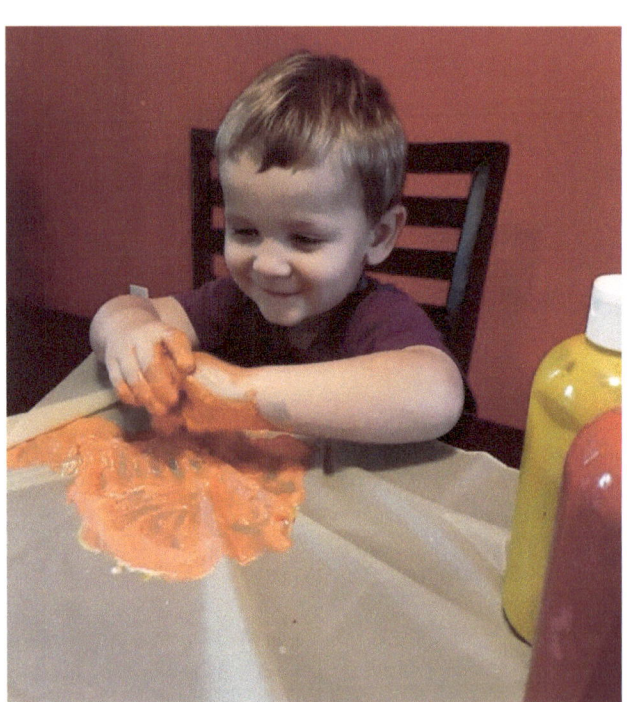

Instructions:

1. Lay out the plastic sheet on the table.
2. Spray two piles of shaving cream onto the table.
3. Add drops of yellow paint to one pile.
4. Add drops of red paint to the other pile.
5. Allow your child to mix and blend the two piles of shaving cream together until it turns orange.

Accompanying activity: *March #3*
Take a walk outside and identify things that are orange.

Two-year-old Curriculum

Unit #3: Mixing Secondary colors
March: Activity #4 – Mixing Primary colors to make purple

FOCUS:
mixing the Primary colors red and blue
to make purple

MATERIALS:
red non-toxic paint
blue non-toxic paint
shaving cream
plastic sheet to cover table

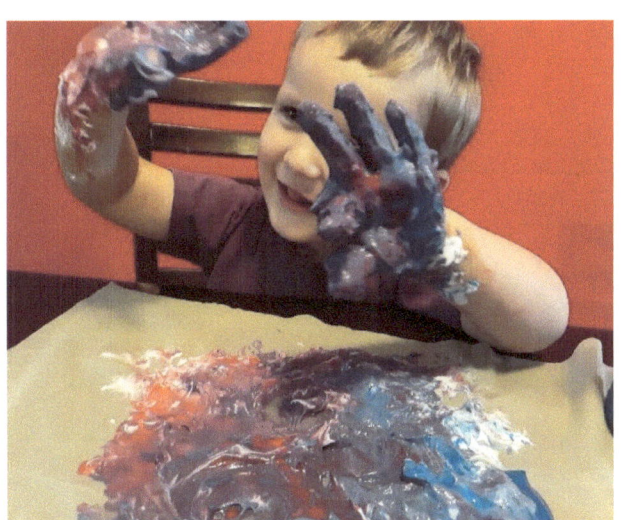

Instructions:

1. Lay out the plastic sheet on the table.
2. Spray two piles of shaving cream onto the table.
3. Add drops of red paint to one pile.
4. Add drops of blue paint to the other pile.
5. Allow your child to mix and blend the two piles until it turns purple.

Accompanying activity: *March #4*
Take a walk outside and identify things that are purple.

Two-year-old Curriculum

Unit #3: Mixing Secondary colors
March: Activity #5 – Painting a Spring Scene with Secondary colors

FOCUS:
mixing Primary colors to make Secondary colors

MATERIALS:
white construction paper
paper plates
red non-toxic paint
blue non-toxic paint
yellow non-toxic paint
Q-tips

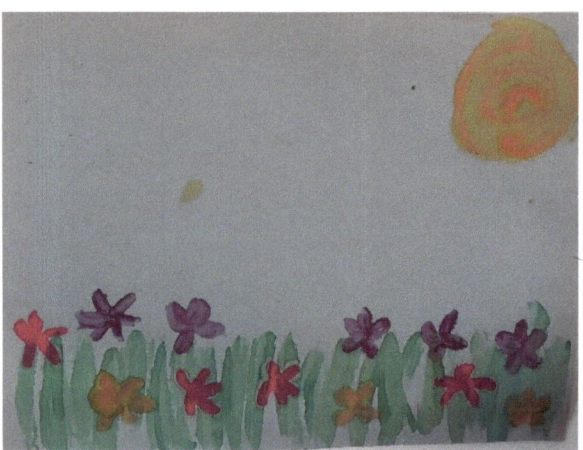

Instructions:

1. Lay out the sheet of paper.
2. Pour a small cookie sized shape of each color paint onto the paper plate.
3. Mix the blue and yellow together to make green for the grass.
4. Paint the grass on the bottom of the paper with fingers.
5. Mix the red and yellow to make orange for the sun.
6. Paint the sun on the top of the paper with fingers.
7. Mix some red and blue to make purple for flowers.
8. Use Q-tips to paint red, orange and purple flowers in the grass.
9. Your child will have such a feeling of accomplishment – like they've created a true masterpiece!

Accompanying activity: *March #5*
Before starting on your Spring scene painting, go for a walk and look at your surroundings. Ask your child to describe your surroundings to you. When you start your painting, ask your child to remember what he or she saw on your walk.

Two-year-old Curriculum

Unit #3: Mixing Secondary colors
March: Activity #6 – Making a Monarch Butterfly

FOCUS:
mixing Primary colors red and yellow
to make orange

MATERIALS:
paper plate
yellow non-toxic paint
red non-toxic paint
black non-toxic paint
Q-tips
googly eyes

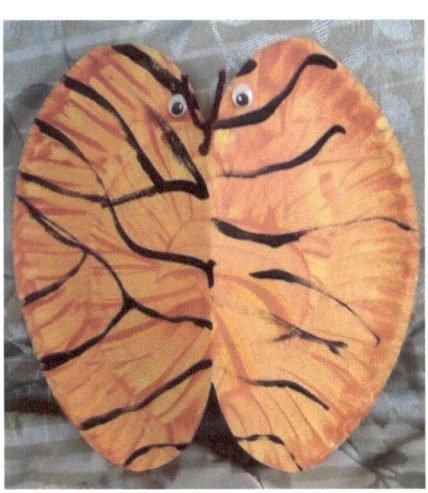

Instructions:

1. Place a large cookie-sized drop of yellow paint on one side of the paper plate.
2. Place another large cookie-sized drop of red paint on the other side of the plate.
3. Have your child mix the paint together on the paper plate with his/her hands to make orange.
4. After the whole plate is colored in, allow the paint to dry.
5. Once the paint is dry, use black paint to make the lines with fingers in the Monarch's wings.
6. Once dry, fold the paper plate in half and trim off each pointy end in a rounded shape, about 2 inches from each end, to round off the ends for wings.
7. If desired you can put a hole punch in the center and put a pipe cleaner through the hole, bending it to make antennae.

Accompanying video: *March #6*
Video: You tube – Monarch butterflies amazing migration to Mexico.
This short video is both beautiful and educational and sure to capture your child's attention.

Two-year-old Curriculum

Unit #3: Mixing Secondary colors
March: Activity #7 – Making a Beetle

FOCUS:
Mixing Primary colors red and blue
to make the Secondary color purple

Materials:
black construction paper
paper plate
red non-toxic paint
blue non-toxic paint
pipe cleaners
googly eyes
scissors
stapler
glue

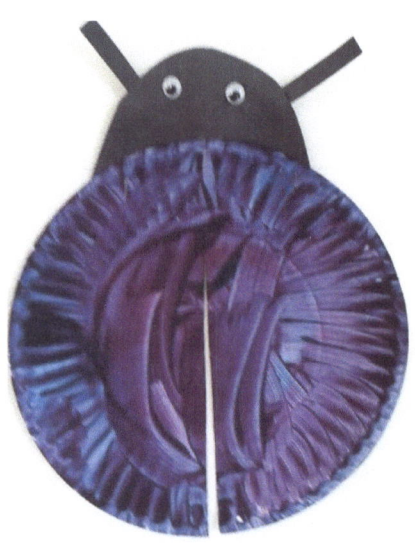

Instructions:

1. Set out paper plate.
2. Put a drop of red paint on one side of the plate.
3. Put a drop of blue paint on the other side of the plate.
4. Allow your child to mix and blend the paint until it makes purple.
5. Let the plate dry.
6. After the plate dries, fold the plate in half with the purple side out.
7. Cut a slit along the fold, stopping 3 inches from the opposite end of the plate.
8. Cut out a black half circle for the beetle's head.
9. Staple the wings to the beetle's head.
10. Then glue googly eyes onto the head.
11. Cut two small strips of black construction paper for antennae if desired.

Accompanying video: *March #7*
Video: You tube – Purple Jewel beetle and giant African fruit beetle.
This very short video is good for getting a close-up look at the beautiful colors of these two beetles.

Two-year-old Curriculum

Unit #3: Mixing Secondary colors
March: Activity #8 – Making a Grasshopper

FOCUS:
mix Primary colors blue and yellow to make green

MATERIALS:
paper plates
pencil
blue non-toxic paint
yellow non-toxic paint
green pipe cleaner
googly eyes
stapler
glue
hole punch

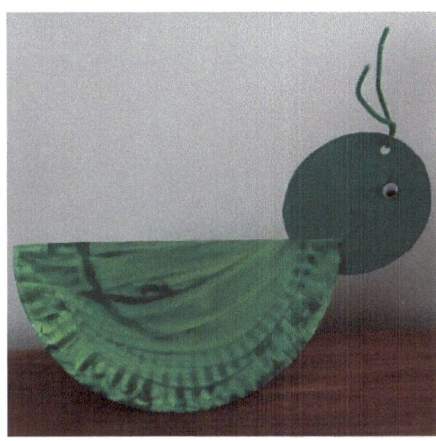

Instructions:

1. Place a large drop of yellow paint on a paper plate.
2. Place a large drop of blue paint on the opposite side of the paper plate.
3. Place a large drop of yellow paint on the second paper plate.
4. Place a large drop of blue paint on the second paper plate.
5. Have your child mix the paint on both paper plates with his/her fingers.
6. Have your child spread the paint thinly over each paper plate.
7. Scoop off the excess.
8. Allow to dry.
9. Fold one paper plate in half with the green side out for the grasshopper's body.
10. Use the included stencil to trace and cut out two equal sized circles from the second paper plate to make the grasshopper's head.
11. Glue the white sides of the small circles for the head together, so that the green sides show.
12. Cut a small slit at the edge of the fold of the body.
13. Place the grasshopper's head into the slit and staple it in place.
14. Glue on googly eyes and make antennae with the green pipe cleaners.
15. Punch a hole in the head and string the pipe cleaner through for antennae.

Accompanying video: *March #8*
You tube – Planet Earth Amateur Edition grasshopper.
This short video gives a great close-up view of a grasshopper climbing a tree.

Grasshopper Head Template

Two-year-old Curriculum

Unit #3: Mixing Secondary colors
April: Activity #1 - Freezing and melting colored glaciers
(this can be separated into three separate activities)

FOCUS:
Mixing the Secondary colors

MATERIALS:
water
6 sandwich sized zip lock bags
red food color
blue food color
yellow food color
3 large white plastic dishpans

Instructions:

1. Fill 6 sandwich size zip-lock baggies with one cup of water each.
2. Add 4 drops of red food coloring to two of the bags.
3. Add 4 drops of blue food coloring to two of the bags.
4. Add 4 drops of yellow food coloring to two of the bags.
5. Zip up the bags and place in the freezer.
6. Allow bags of ice to freeze solid overnight.
7. Once the ice is frozen, cut two bags open at a time in the following order:
 (Melting these two bags of Primary colors together will make the Secondary colors.)
8. Place one yellow and one blue glacier bag into the same dishpan together and allow to melt to make green.
9. Place one yellow and one red glacier bag into another dishpan together and allow to melt to make orange.
10. Place one red and one blue glacier bag into another dishpan and allow to melt to make purple.

Accompanying reading: *April #1*
Book: Glaciers: Nature's Icy Caps

Two-year-old curriculum

UNIT #4

Two-year-old curriculum

Unit Four Introduction and explanation:

Unit four of The Two-year-old curriculum and activity book also continues to focus on basic skills. The unit takes a relook at and review of the Primary colors red, blue and yellow and mixing the Secondary colors green, orange and purple. As you reinforce the names of the Primary and Secondary colors, your child will simultaneously be learning to manipulate paint with his/her fingers, hands and Q-tips. The activities in this unit will provide fine motor skill exercises for your child.

As you play through this unit with your child, encourage him/ her to repeat the vocabulary words as you talk about each activity.

Vocabulary:

Red	Green
Blue	Orange
Yellow	Purple
Finger print	Thumb print
Spider	Frog
Lion	Flamingo
Flower	

Learning styles addressed:
Visual
Kinesthetic
Fine motor

Learning Links:
Art- colors: red, blue, yellow, green, orange, purple

Physical activity: manipulation of paint

Science: animals and their habitats, plants and their environments.

Two-year-old Curriculum

Unit #4: Painting with fingers and other objects
April: Activity #2 – Using fingers to mix the tint light blue

FOCUS:
mixing blue and white to make light blue

MATERIALS:
large sheet of white paper
paper plate
blue non-toxic paint
white non-toxic paint

Instructions:

1. Lay out the paper.
2. Put a large drop of white paint on the plate.
3. Put a smaller drop of blue paint on the other side of the plate.
4. Allow child to mix the blue and white paint together with fingers.
5. Once a light blue is achieved, use fingers to put dots on the large white paper to make rain drops.
6. You have created a rainy-day scene!

Accompanying activity: *April #2*
Take a walk outside. Notice the color of the sky. It can be blue or light blue. As you look around notice the colors of the plants. Is the sun orange or yellow?

Two-year-old Curriculum

Unit #4: Painting with fingers and other objects
April: Activity #3 – Making a Creepy spider

FOCUS:
Finger painting

MATERIALS:
white construction paper
black non-toxic paint
fine tip black Sharpie marker

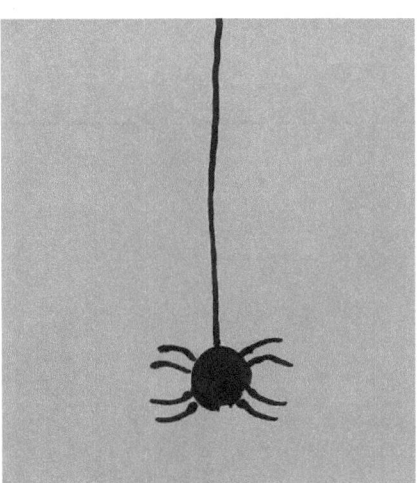

Instructions:

1. Lay out the white paper.
2. Dip your child's thumb into the black paint.
3. Place your child's thumb onto the paper and press to form a fingerprint.
4. Allow your child to use the black Sharpie to make lines next to the thumbprint to form spider legs.
5. Draw a line from the spider's head to the top of the page, as if the spider is hanging from his web.

Accompanying movie: *April #3*
Movie – Watch the movie Charlotte's web. Talk about the good spider.

Two-year-old Curriculum

Unit #4: Painting with fingers and other objects
April: Activity #4 – Making a Hoppy frog

FOCUS:
Finger painting

MATERIALS:
construction paper (color optional)
green non-toxic paint
fine tip black Sharpie marker

Instructions:

1. Lay out the paper.
2. Dip your child's thumb into the paint.
3. Place your child's thumb onto the paper and press to form a fingerprint.
4. Dip the child's thumb into the paint again and place the second fingerprint on top of the first fingerprint.
5. You now have the head and body of the frog.
6. Allow your child to use the sharpie to make eyes and legs.
7. Optional: you may place your frog on a lily pad.

Accompanying activity: *April #4*
Take a walk in the park by the pond. See if you can find any frogs jumping.

Two-year-old Curriculum

Unit #4: Painting with fingers and other objects
April: Activity #5 - Making a Happy butterfly

FOCUS:
Finger painting

MATERIALS:
white construction paper
paper plate
non-toxic paint (color of choice)
fine tip black Sharpie marker

Instructions:

1. Lay out the white sheet of paper.
2. Place a large drop of paint onto the paper plate.
3. Dip your child's thumb into the paint.
4. Place your child's thumb onto the paper and press to form a fingerprint.
5. Dip your child's thumb into the paint again.
6. Place thumb on paper and press to form a fingerprint directly under the first fingerprint.
7. Dip child's thumb into paint again.
8. Place your child's thumb onto the paper and press to form a fingerprint directly next to the first fingerprint.
9. Dip your child's thumb into the paint again.
10. Place your child's thumb onto the paper and press to form a fingerprint directly next to the second fingerprint.
11. Now you have the butterfly's wings.
12. Draw a line between the butterfly's wings with the Sharpie to create the body.
13. Then use the Sharpie to draw on antennae.

Accompanying activity: *April #5*
Take a walk outside. See if there are any butterflies flying. Can you catch one?

Two-year-old Curriculum

Unit #4: Painting with fingers and other objects
April: Activity #6- Finger painting a Friendly Lion

FOCUS:
Finger painting

MATERIALS:
white construction paper
paper plate
yellow non-toxic paint
brown non-toxic paint
paint brush
fine tip black Sharpie marker

Instructions:

1. Lay out the white sheet of paper.
2. Place a large drop of yellow paint onto the paper plate.
3. Use the paintbrush to paint a yellow circle for the lion's head.
4. Then place your child's thumbs into the brown paint.
5. Make brown thumbprints all around the yellow circle to make the lion's mane, dipping thumb back into the paint when necessary.
6. After the paint dries, draw a face on with the Sharpie marker.

Accompanying activity: *April #6*
Go to your local zoo. Find the lions and the Flamingos

Accompanying reading: *April #6*
Book: Peek-A-Boo Zoo

Two-year-old Curriculum

Unit #4: Painting with fingers and other objects
April: Activity #7 – Finger painting a flower

FOCUS:
Finger painting

MATERIALS:
white construction paper
paper plate
red non-toxic paint
yellow non-toxic paint
green Sharpie marker

Instructions:

1. Lay out the white sheet of paper.
2. Place a large drop of yellow paint onto the paper plate.
3. Dip your child's thumb into the yellow paint.
4. Make a thumbprint for the center of the flower.
5. Place a large drop of red paint onto the paper plate.
6. Dip your child's index fingers into the red paint and make fingerprints around the center for petals.
7. Draw a stem with the sharpie.

Accompanying activity: *April #7*
It's springtime! Choose a pretty flower and plant it in a pot or in the flower bed.

Two-year-old Curriculum

Unit #4: Painting with fingers and other objects
April: Activity #8 – Painting a Flamingo

FOCUS:
Painting with hands

MATERIALS:
blue construction paper
paper plates
pink non-toxic paint
white non-toxic paint
yellow non-toxic paint
green non-toxic paint
paint brush
googly eyes
glue
fine tip black Sharpie marker

Instructions:

1. Lay out the paper.
2. Place a large drop of pink paint onto a paper plate.
3. Dip your child's hand into the pink paint.
4. Place your child's hand onto paper to make a handprint.
5. Turn the paper upside down.
6. Assist your child with painting on the legs and beak with yellow paint, using the paintbrush.
7. Assist your child with painting on the green grass with a paintbrush.
8. Then, with the white, make some ripples in the water with the paintbrush.
9. When the body is dry, use the white paint for a feather on the side of the body.
10. Glue on a googly eye.
11. Use a marker to tip the nose.

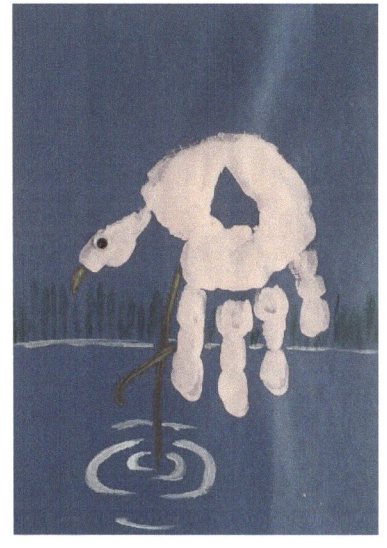

Accompanying activity: *April #8*
Go to your local zoo. Find the lions and the Flamingos

Accompanying reading: *April #8*
Book: Peek-A-Boo Zoo

Two-year-old curriculum

Unit #4: Painting with fingers and other objects
May: Activity #1- Painting a Primary color Dayscape

FOCUS:
Finger painting using Primary colors
Colors: red, blue, yellow

MATERIALS:
white construction paper
paper plates
red non-toxic paint
blue non-toxic paint
yellow non-toxic paint
Q-tips

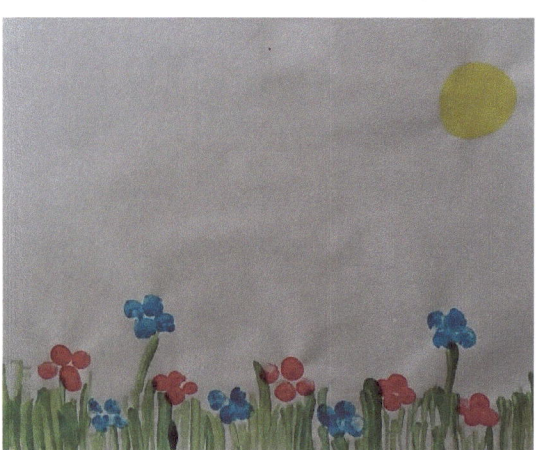

Instructions:

1. Lay out the white sheet of paper.
2. Place a teaspoon-sized drop of red paint onto a paper plate.
3. Place a teaspoon-sized drop of blue paint onto a paper plate.
4. Place a teaspoon-sized drop of yellow paint onto a paper plate.
5. Lay out the white construction paper.
6. Allow your child to use yellow paint to paint the sun in the top half of the paper with his/her finger.
7. Use red and blue and paint flowers using finger prints near the bottom of the page.
8. If desired, mix blue and yellow to make green for grass and use Q-tips to paint it onto the paper.
9. You have created a dayscape!

Accompanying reading: *May #1*
Book: Where is Little Fish

Two-year-old curriculum

Unit 4: Painting with fingers and other objects
May: Activity #2 - Ocean scene

FOCUS:
Mixing Primary colors to make
Secondary colors

MATERIALS:
blue construction paper
paint brush
red non-toxic paint
blue non-toxic paint
yellow non-toxic paint
white non-toxic paint
googly eyes
glue
fine tip black Sharpie marker

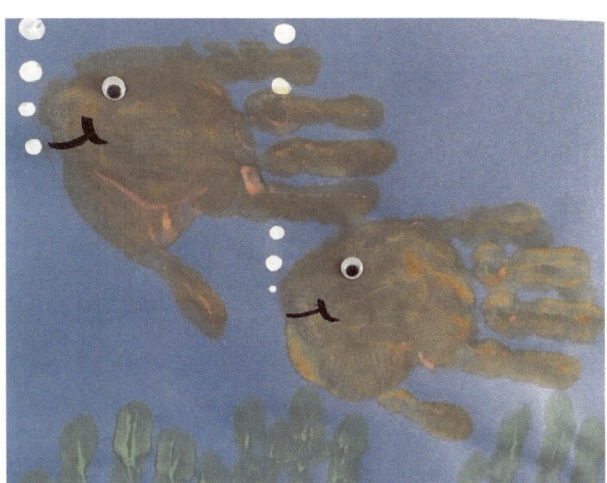

Instructions:

1. Lay out the blue construction paper.
2. Mix red and yellow paint to make orange for the fish.
3. With the paintbrush, paint your child's hand orange.
4. Place your child's hand onto the blue paper to make a handprint.
5. Then, mix the yellow and blue paint to make green for the seaweed.
6. Paint your child's fingers green.
7. Place your child's fingers on the bottom side of the paper to make the seaweed.
8. After the fish have dried, glue on googly eyes for the fish eyes.
9. Draw on mouths with the Sharpie.
10. Dip pointer finger into the white paint and make bubbles coming from the fish mouths.

Accompanying reading: *May #2*
Book: Where is Little Fish

Two-year-old curriculum

UNIT #5

Two-year-old curriculum

Unit Five Introduction and explanation:

Unit five of The Two-year-old curriculum and activity book again focuses on basic skills. In this unit your child will advance from using fingers and hands to paint to manipulating a paint brush. This activity provides practice in fine motor skill exercises for your child. In addition to learning to manipulate the paint brush, your child will be learning to recognize patterns. The patterns stripes and spots are introduced. Keep in mind that, at this age, skills are limited, and each effort deserves applause!

As you play through this unit with your child, encourage him/ her to repeat the vocabulary words as you talk about each activity.

Vocabulary:
Red	Purple
Black	White
Brown	
Pattern	Stripes
Spots	

Learning styles addressed:
Visual
Kinesthetic
Fine motor

Learning Links:
Art- colors: red, purple, black, white, brown
 Pattern: stripes, spots

Physical activity: manipulation of paintbrush

Science: animals and insects

Two-year-old Curriculum

Unit 5: Painting with the brush
May: Activity #3 - Purple Emperor butterfly

FOCUS:
painting with the brush

MATERIALS:
paper plate
pencil
red non-toxic red paint
blue non-toxic blue paint
one large paint brush
two small paint brushes
scissors
googly eyes
glue
black pipe cleaner

Instructions:

1. Place a drop of red paint and a drop of blue paint onto the paper plate on opposite sides.
2. Allow your child to mix the paints together using the large brush.
3. Allow the plate 5-10 minutes to dry, explaining to the child that you are waiting for the paint to dry.
4. Have your child blow on the paper plate with you to speed drying (this will keep your child from getting bored).
5. Once the paint is dry, fold the paper plate in half with the colored side facing out.
6. Round off the pointed ends of the paper plate with scissors to form into butterfly wings.
7. Use a small paintbrush with black paint to go around the edges of the wings.
8. When finished with the wing outline, use a small brush with white paint to brush a white stripe onto the wings.
9. Allow to dry.
10. When finished, glue googly eyes onto the butterfly.
11. Use a black pipe cleaner to make antennae. (*Optional)

Accompanying reading: *May#3*
Book: Mr. Peanuckle's Bug Alphabet

Two-year-old Curriculum

Unit #5: Painting with the brush
May: Activity #4 – Painting a Lady Bug

FOCUS:
Painting with the brush

MATERIALS:
two paper plates
black construction paper
red non-toxic paint
black non-toxic paint
large paintbrush
small paintbrush
glue
googly eyes

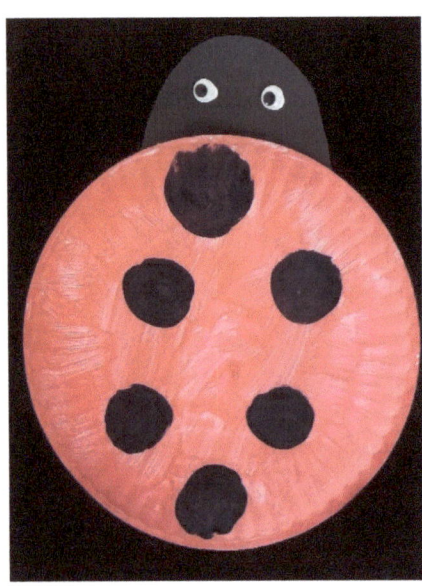

Instructions:

1. Place a drop of red paint on one paper plate.
2. Allow your child to paint the whole paper plate red, using a paint brush.
3. Place a drop of black paint on another paper plate.
4. Using the small brush, dip the brush into the black paint.
5. Allow your child to make dots on the red paper plate with the paintbrush to create a ladybug.
6. Cut out a circle for the head from the black construction paper.
7. Glue the head to the paper plate.
8. Next, you can glue on googly eyes.
9. You can use black pipe cleaners for antennae. (*optional)

Accompanying reading: *May#4*
Book: Mr. Peanuckle's Bug Alphabet

Two-year-old Curriculum

Unit #5: Painting with the brush
May: Activity #5 – Painting a Zebra

FOCUS:
Painting a pattern using the brush

MATERIALS:
white construction paper
paper plate
black non-toxic paint
paint brush
picture of a zebra

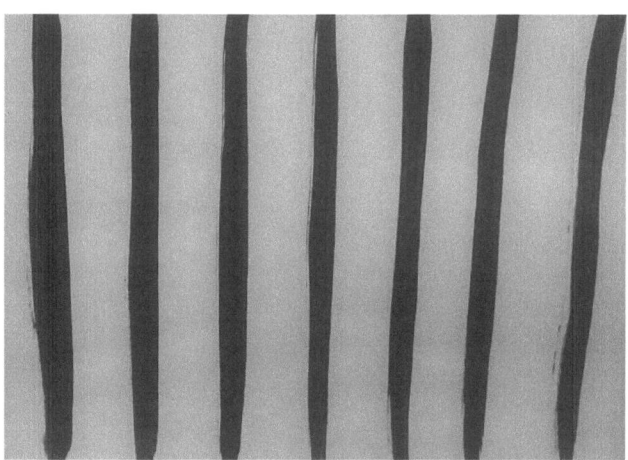

Instructions:

1. Lay out the white sheet of paper.
2. Show your child some pictures of a zebra.
3. Discuss the stripes on the zebra.
4. Allow your child to make black stripes on the white paper with the paint brush to make zebra stripes.

Accompanying reading: *May#5*
Book: Peek-A-Boo zoo by Jane Cabrera

Two-year-old Curriculum

Unit #5: Painting with the brush
May: Activity #6 – Painting a Zebra - opposite

FOCUS:
Painting a pattern with the brush

MATERIALS:
black construction paper
paper plates
white non-toxic paint
paint brush
picture of a zebra

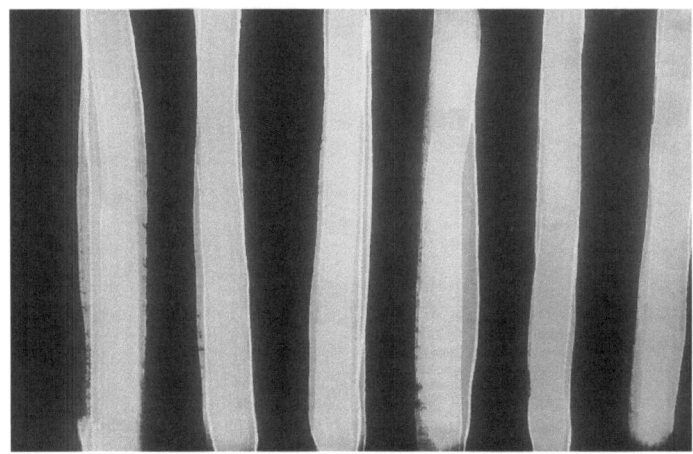

Instructions:

1. Lay out the sheet of black paper.
2. Show your child pictures of a zebra and discuss the picture you made with the black stripes on white paper.
3. Ask your child what would happen if you put white stripes on black paper.
4. Allow your child to paint white stripes on the black paper like zebra stripes.
5. Just for fun, ask your child if the zebra has white stripes on a black body or black stripes on a white body.

Accompanying reading: *May#6*
Book: Peek-A-Boo zoo by Jane Cabrera

Two-year-old Curriculum

Unit #5: Painting with the brush
May: Activity #7 -Painting a Giraffe with a brush

FOCUS:
Painting a pattern with the brush

MATERIALS:
white construction paper
red construction paper
paper plates
orange non-toxic paint
brown non-toxic paint
paint brushes
paper towel roll tube
tape
scissors
large googly eyes
glue
picture of a giraffe
giraffe head template – provided

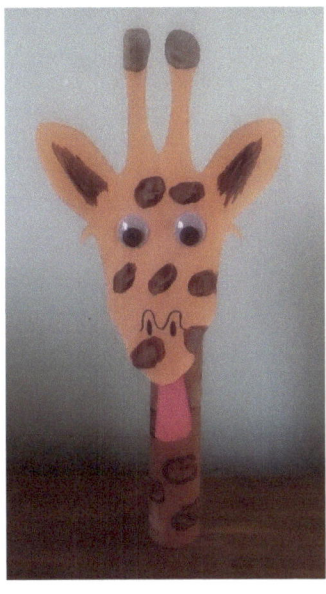

Instructions:

1. Lay out the white sheet of paper.
2. Place a drop of orange paint onto a paper plate.
3. Allow your child to paint this color all over the cardboard tube for the giraffe neck.
4. Trace the template for the giraffe head onto the white paper.
5. Using the scissors, cut out the giraffe's head.
6. Allow child to paint the giraffe's head orange with the brush.
7. Let the tube and head dry.
8. Once dry, glue the googly eyes on.
9. Tape the head to the tube.
10. Now the head is taped to the neck.
11. Using the brush, allow your child to make spots all over the giraffe with brown paint.
12. Use the sharpie to draw on the nose.
13. Last, cut a strip of red construction paper and tape it to the face for the tongue.

Accompanying reading: *May#7*
Book: Peek-A-Boo zoo by Jane Cabrera

Giraffe Template

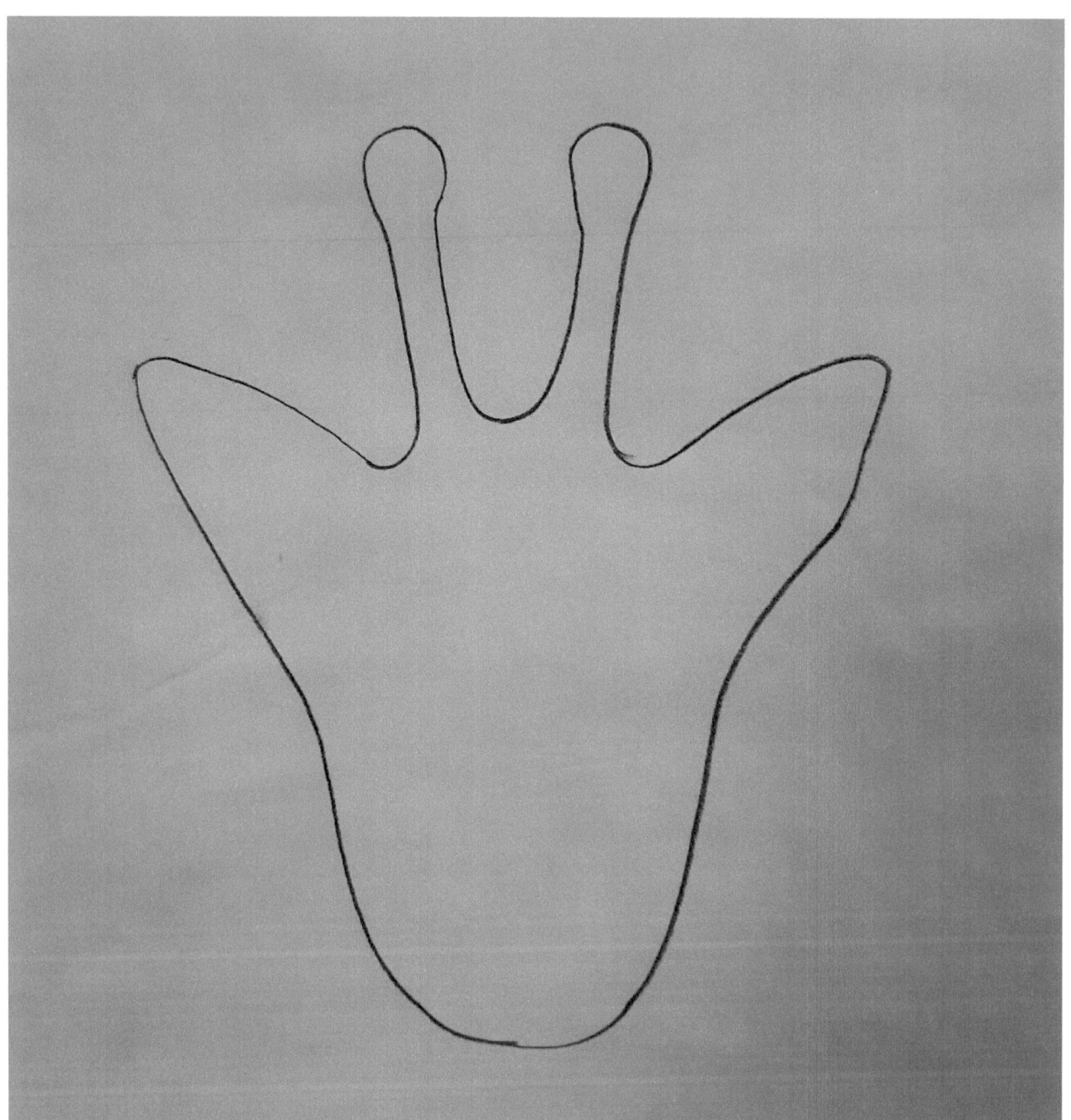

Two-year-old Curriculum

Unit #5: Painting with the brush
May: Activity #8 – Painting a Cheetah pattern

FOCUS:
Painting a pattern with the brush

MATERIALS:
white construction paper
paper plates
orange non-toxic paint
brown non-toxic paint
black non-toxic paint
two medium sized paint brushes
picture of a Cheetah

Instructions:

1. Lay out the sheet of paper.
2. Show your child a picture of a Cheetah.
3. Discuss the picture of the zebra you made and explain that now you are going to paint a Cheetah.
4. Place a drop of orange paint onto a paper plate.
5. Allow your child to use the brush to paint all over the paper with the orange paint.
6. Place a drop of black paint onto another paper plate.
7. Place a drop of brown onto the same paper plate as the black paint.
8. Allow your child to mix the black and brown together with the other paint brush.
9. Dip a brush into the mixture of black and brown and make Cheetah spots on the orange paper.

Accompanying reading: *May#8*
Book: Peek-A-Boo zoo by Jane Cabrera

Two-year-old Curriculum

Unit #5: Painting with the brush
June: Activity #1 – Dalmatian

FOCUS
Painting a pattern with a brush

MATERIALS:
white construction paper
paper plates
black non-toxic paint
one large paint brush
one small paint brush
pictures of a Dalmatian

Instructions:

1. Lay out the sheet of paper.
2. Look at the Dalmatian pictures & discuss the pattern of its fur.
3. Using the black paint and different sized brushes, make spots on the white paper to create a Dalmatian pattern.

Accompanying movie: *June#1*
Movie: 101 Dalmatians

Two-year-old curriculum

UNIT #6

Two-year-old curriculum

Unit six Introduction and explanation:

Unit six of The Two-year-old curriculum and activity book will have you and your child experimenting with crayons, sidewalk chalk and large dot markers. Notice the difference in how they feel. You and your child will have fun experimenting with colors as you create things in your environment. This unit's activities once again provide fine motor skill exercises for your child.

As you play through this unit with your child, encourage him/her to repeat the vocabulary words as you talk about each activity.

Vocabulary:
Family Animal
Rhinoceros Starfish
Beach Sand
Draw Trace
Dots

Learning styles addressed:
Visual
Kinesthetic
Fine motor

Learning Links:
Art- drawing, tracing, coloring

Science- animals and their habitats

Sociology- families and their similarities and differences

Two-year-old curriculum

Unit #6: Drawing
June: Activity #2 – Drawing a family

FOCUS:
Drawing with a crayon

MATERIALS:
white construction paper
assorted Crayons

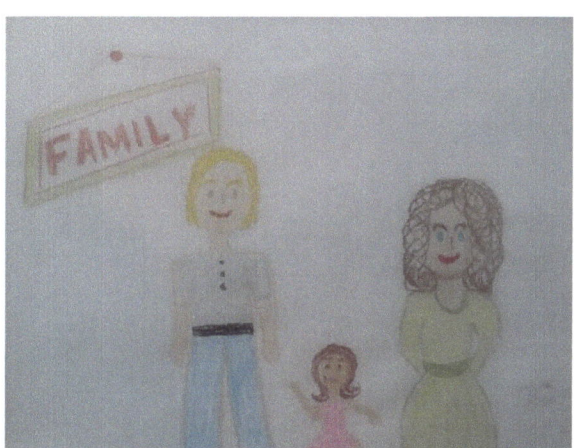

Instructions:

1. Lay out the white paper.
2. Lay out the crayons.
3. Talk to your child about the members of your family and notice that some families are different. Some families have mommies and daddies. Some families have grandmas living with them.
4. Tell your child that today you are going to draw a family using crayons.
5. Allow your child to draw some members of the family, freely expressing what family looks like in the child's eyes.

Accompanying activity: *June #2*
Talk with your child about the people in your family. Do you have a traditional or non-traditional family? What do the people in your family look like? Look at the people in other families. Do they look the same or different as yours?

Accompanying reading: *June #2*
Book: Last stop on Market street by Matt de la Pina.
This is a great book about a grandmother and her grandson taking a trip across town. It is illustrated by Christian Robinson.

Unit #6: Drawing
June: Activity #3- Drawing an animal

FOCUS:
Drawing with a crayon

MATERIALS:
white construction paper
assorted crayons

Instructions:

1. Lay out the white paper.
2. Lay out assorted crayons.
3. Talk to your child about pets that you have or animals you have seen at the zoo or on t.v.
4. Tell your child that today you are going to draw a picture with crayons.
5. Allow your child to draw a favorite animal.
6. After your child has drawn the animal, ask your child about where the animal lives and what it eats.

Accompanying activity: *June #3*
Take a trip to your local zoo. Look at the animals. See how many you can name. What colors are they? What do they eat?

Accompanying reading: *June #3*
Book: Are You My Mother? By P.D. Eastman

Two-year-old curriculum

Unit #6: Drawing
June: Activity #4 – Drawing with sidewalk chalk

FOCUS:
Drawing with sidewalk chalk

MATERIALS:
sidewalk chalk
Access to a sidewalk or patio

Instructions:

1. Go outside.
2. Give your child the sidewalk chalk.
3. Talk to your child about what you see outside. There are trees and flowers.
4. Ask your child to draw something in the environment that they see.
5. Children love to draw on the concrete! Your child may ask you to help draw something.

The collaboration you two come up with will, no doubt, be a beautiful picture and precious time together!

Accompanying activity: *June #4*
Draw a picture on the chalk board. Notice how the chalk feels different on the sidewalk than it does on the chalk board.

Accompanying video: *June #4*
Video: Sidewalk chalk props for Kids Photography – You Tube
This is a cute video that shows children in the artwork. Your child may ask you to create some of these terrific scenes, so he can sit in them!

Two-year-old curriculum

Unit #6: Drawing
June: Activity #5 – Starfish handprint

FOCUS:
Drawing with crayon

MATERIALS:
White construction paper
orange crayon
assorted crayons

Instructions:

1. Lay out the paper.
2. Lay your child's hand on the paper.
3. Holding your child's hand still, help your child trace it with the orange crayon.
4. After tracing the hand, you can color or dot it to look like a starfish.
5. Once the starfish is finished, add some ocean plants, sand or fish!

Accompanying video: *June #5*
Don Marco – The Master Crayon Artist – Don Marco Gallery
Don Marco shows what can be done using Crayola crayons. I was truly amazed when I first saw his work. His attention to detail is impeccable. His work is something that will make an impression.

Two-year-old curriculum

Unit #6: Drawing
June: Activity #6 – Using dot/ bingo markers

FOCUS:
Using dot markers

MATERIALS:
white construction paper
one dot marker of your child's favorite color

Instructions:

1. Lay out the construction paper.
2. Give your child the marker and allow him/ her to make any kind of mark he/she wants to.

Using these large markers will give your child the confidence to manipulate objects in the environment.

Accompanying activity: *June #6*
As you go about your daily routine, notice circles or dots that match the color of your dot marker. Maybe you notice a polka dot pattern on someone's dress, or on wrapping paper.

Two-year-old curriculum

Unit #6: Drawing
June: Activity #7 - Making an Octopus

FOCUS:
Using crayons to make shapes

MATERIALS:
white construction paper
crayon of choice

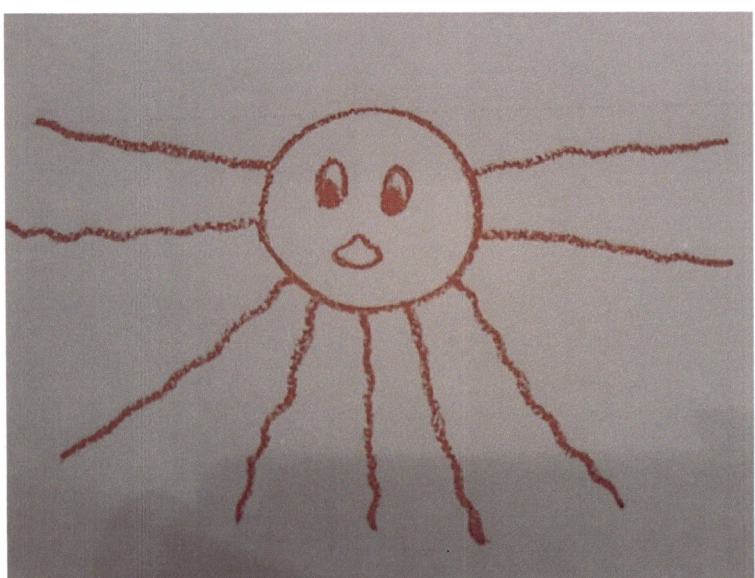

Instructions:

1. Lay out the paper.
2. Help your child make a circle on the paper.
3. Help your child make lines coming out from the circle for the legs of the Octopus.
4. Help your child draw eyes and a mouth for your octopus.

Accompanying activity: *June #7*
While swimming at the pool, pretend you are an Octopus. You can go into your cave or look for food.

Accompanying website: *June #7*
Etsy
If you pull up the Etsy website and type in Octopus paintings, you will see a wide variety of Octopi in varied media. I chose this website due to the difficulty in finding an artist who paints only Octopi.

Two-year-old curriculum

Unit #6: Drawing
June: Activity #8 - Drawing a beach scene - Feet Fun

FOCUS:
Drawing with crayons

MATERIALS:
white construction paper
assorted crayons
assorted markers

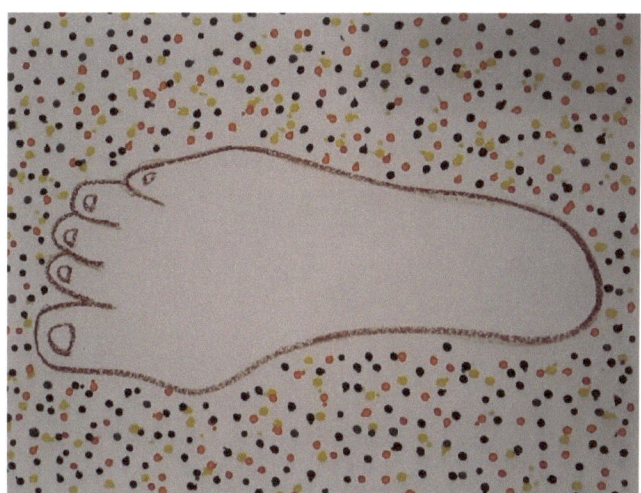

Instructions:

1. Lay out the paper.
2. Have your child stand on the paper.
3. Trace the child's feet with the marker.
4. Let your child use markers to dot all around the footprints to look like sand.
5. Your child can add additional items such as shells, shovel and a pale.

Accompanying activity: *June #8*
While at the beach, notice your footprints in the sand. Notice the tiny grains of sand. If you can't get to the beach, make footprints with water on the concrete at the pool or on the sidewalk. Notice the little pebbles in the concrete.

Accompanied website: *June #8*
Kay Crain
If you look up Kay Crain's website, under pool and beach, there are many paintings of beach scenes with children and families.

Two-year-old curriculum

UNIT #7

Two-year-old curriculum

Unit seven Introduction and explanation:

In Unit seven of the two-year-old curriculum and activity book you and your child will look at traditions of the Fourth of July! You will learn about the American flag and get super-sparkly creating your own fireworks! By introducing a variety of media, you and your child will have hours of fun!

As you play through this unit with your child, encourage him/her to repeat the vocabulary words as you talk about each activity.

Vocabulary:
American flag

Stars	stripes
draw	lines
drawing	crayon
paint	painting
red	marker
blue	glue
glitter	fireworks

Learning styles addressed:
Visual
Kinesthetic- fine motor

Learning Links:
Art- drawing with a crayon and a marker,
painting with the brush

American history- American flag

Unit #7: All American activities
July: Activity # 1 - American Flag

FOCUS:
Drawing and painting

MATERIALS:
white construction paper
paper plates
red non-toxic paint
blue non-toxic paint
paint brush
white crayon
fine tip black Sharpie marker
wipes

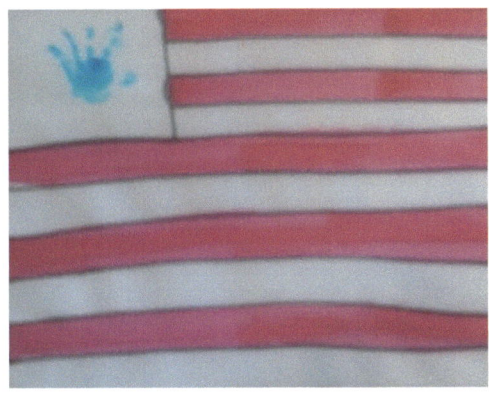

Instructions:

1. Lay out the sheet of paper.
2. Using the black marker, draw a square in the upper left corner of the paper.
3. Draw straight lines across the page, like drawing lines for the stripes of the American flag.
4. Put some red paint onto one paper plate.
5. Put some blue paint onto another plate.
6. Dip your child's hand into the blue paint.
7. Place your child's hand with the blue paint on it inside the square, making a handprint.
8. Clean off your child's hand with the wipes.
9. Dip the brush into the red paint and have your child paint inside every other stripe, making the stripes of the American flag.
10. Once the paint is dry, your child can use the white crayon to draw stars inside the blue handprint.

Accompanying video: *July #1*
Video: Chris Pratt Pledge of Allegiance
Watch this video and teach your child the Pledge of Allegiance.

Accompanying video: *July #1*
Video: Betsy Ross and the First United States Flag for students, kids
This is a good video with good information! Even you may learn something!

Two-year-old curriculum

Unit #7: All American activities
July: Activity #2 – Creating fireworks

FOCUS:
Manipulating glue.
Noticing different effects of glitter on white paper

MATERIALS:
white construction paper
red glitter glue
blue glitter glue
silver glitter glue

Instructions:

1. Lay out the piece of white construction paper.
2. Using the red glitter glue, help your child squeeze it onto the paper to make streaks.
3. Using the blue glitter glue, help your child squeeze it onto the paper to make streaks.
4. Using the silver glitter glue, help your child squeeze it onto the paper to make streaks.
5. You have created a fireworks display!

Accompanying activity: *July #2*
Go outside after its dark and light up your own sparklers.
Go to see your local fireworks display for the 4th of July.

Two-year-old curriculum

Unit #7: All American activities
July: Activity #3 – Creating fireworks at night

FOCUS:
Manipulating glue.
Noticing different effects of glitter on black

MATERIALS:
black construction paper
red glitter glue
blue glitter glue
silver glitter glue

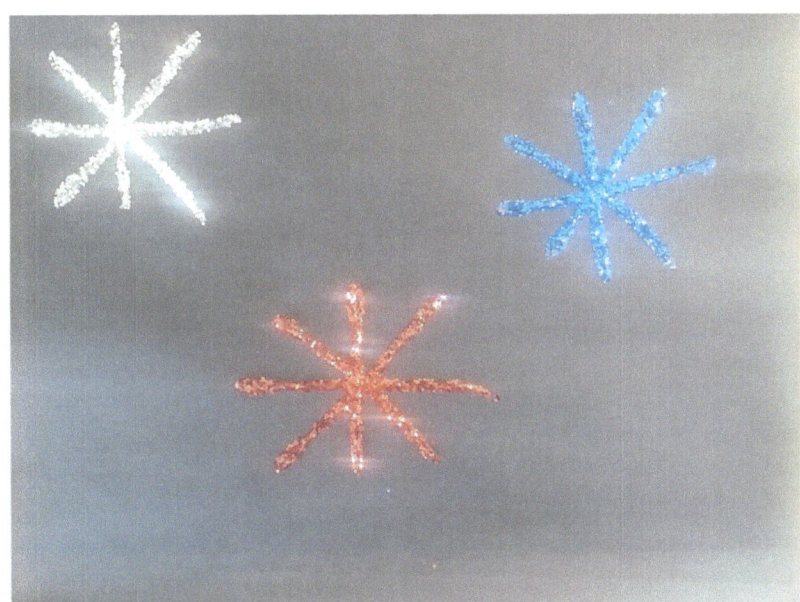

Instructions:

1. Lay out the piece of black construction paper.
2. Using red glitter glue, help your child squeeze it onto the paper to make streaks.
3. Using blue glitter glue, help your child squeeze it onto the paper to make streaks.
4. Using silver glitter glue, help your child squeeze it onto the paper to make streaks.
5. You have a created a night time fireworks display!

Accompanying activity: *July #3*
Go outside after its dark and light up your own sparklers.
Go to see your local fireworks display for the 4th of July.

Two-year-old curriculum

Unit #7: All American activities
July: Activity #4 - Painting fireworks on white

FOCUS:
Creating designs by blowing paint with a straw

MATERIALS:
white construction paper
red non-toxic paint
blue non-toxic paint
Silver non-toxic paint
straw

Instructions:

1. Lay out the sheet of paper.
2. Place a nickel sized drop of red paint on the white paper.
3. Place a nickel sized drop of blue paint on the white paper.
4. Place a nickel sized drop of silver paint on the white paper.
5. Show your child how to move the paint across the paper by blowing on it gently through the straw.
6. Give the straw to your child, allowing your child to blow the paint to make fireworks.
7. You now have a fireworks display!

Accompanying website: *July #4*
Website: 75 Explosive Photos of Fireworks – Gizmodo
There are some fantastic photographs here by a variety of artists.

Unit #7: All American activities
July: Activity #5 - Painting fireworks on black

FOCUS:
Creating designs by blowing paint with a straw

MATERIALS:
black construction paper
red non-toxic paint
blue non-toxic paint
white non-toxic paint
straw

Instructions:

1. Lay out the sheet of paper.
2. Place drop of red paint on the black paper.
3. Place drop of blue paint on the black paper.
4. Place drop of white paint on the black paper.
5. Show your child how to move the paint across the paper by blowing on it gently through the straw.
6. Give the straw to your child, allowing your child to blow the paint to make designs that look like fireworks.
7. You now have a night time fireworks display!

*Note:
If the paint is too thick to blow, add a little water to it.

Accompanying website: *July #5*
Website: 75 Explosive Photos of Fireworks – Gizmodo

Two-year-old curriculum

Unit #7: All American activities
July: Activity #6 - Painting textured fireworks on white

FOCUS:
Creating designs by
painting with shaving cream

MATERIALS:
white construction paper
red non-toxic paint
blue non-toxic paint
shaving cream

Instructions:

1. Lay out the sheet of paper.
2. Spray some dots of shaving cream onto the paper.
3. Put a little of each color paint on each dot of shaving cream.
4. Allow your child to create red, white and blue fireworks by mixing the paint into the shaving cream.
5. Once the shaving cream dries, there will be three dimensional fireworks!

Accompanying reading: *July #6*
Book: Daniel's First Fireworks

Two-year-old curriculum

Unit #7: All American activities
July: Activity #7 - Painting textured fireworks on black

FOCUS:
Creating designs by
painting with shaving cream

MATERIALS:
black construction paper
red non-toxic paint
blue non-toxic paint
shaving cream

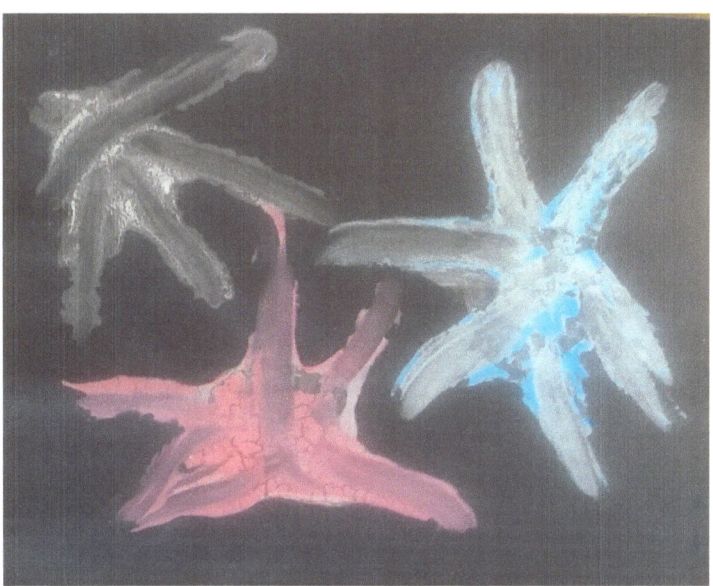

Instructions:

1. Lay out the sheet of black paper.
2. Spray some shaving cream onto the paper.
3. Put a little of each color paint on opposite sides of the paper.
4. Allow your child to create red, white and blue fireworks by mixing the paint into the shaving cream.
5. Once the shaving cream dries, there will be three-dimensional fireworks at night!

Accompanying reading: *July #7*
Book: Daniel's First Fireworks

Two-year-old curriculum

Unit #7: All American activities
July: Activity #8 - Painting textured fireworks

FOCUS:
Using glitter and glue to make designs

MATERIALS:
black construction paper
red glitter
blue glitter
silver glitter
Elmer's glue

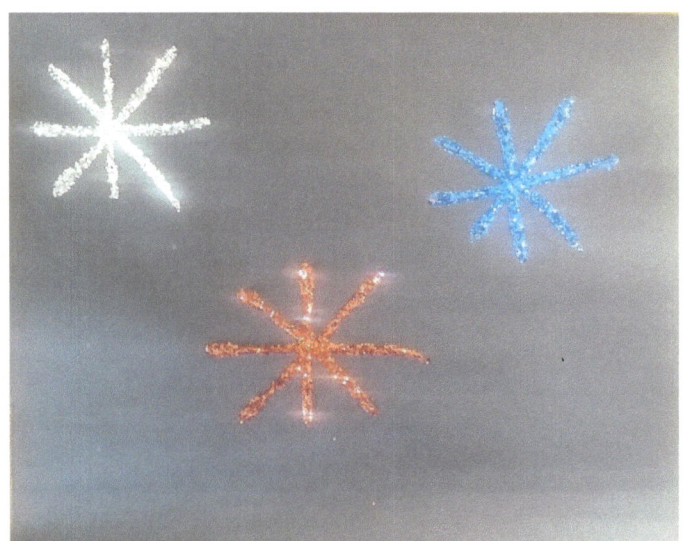

Instructions:

1. Lay out the construction paper.
2. Open the glue bottle.
3. Show your child how to squeeze the glue onto the paper.
4. Let your child squeeze some glue onto the paper.
5. Show your child how to sprinkle glitter onto the glue by gently shaking the glitter bottle above the glue.
6. Help your child sprinkle some glitter onto the glue.
7. Now you have beautiful nighttime fireworks!

Accompanying reading: *July #8*
Book: The night before the fourth of July by Natasha Wing

Two-year-old curriculum

UNIT #8

Two-year-old curriculum

Unit eight Introduction and explanation:

Unit eight of The Two-year-old curriculum and activity book is a mixed match of activities. You and your child will experiment with a variety of media including: Pottery, sculpture and texture. Hands will get messy in this unit as you and your child use fine motor skills to feel and manipulate a variety of media! Beading will Introduce you to coordination skills and dot markers will be used for patterning. In addition, you will have plain old fun while making bubble paint pictures!

As you play through this unit with your child, encourage him/her to repeat the vocabulary words as you talk about each activity.

Vocabulary:
Ball bubbles
Roll blow
Squeeze design
dot marker pattern
Primary colors
red
blue
yellow

Learning styles addressed:
Visual
Kinesthetic- fine motor, sensory

Learning Links:
Art- using play doh as clay,
 Touching texture,
 recognizing Primary colors
 jewelry making

Math – making patterns

Two-year-old curriculum

Unit #8: Mixed up miscellaneous
August: Activity #1 - Introduction to pottery - Making a ball

FOCUS:
Manipulating the shape of Play-doh

MATERIALS:
play-doh

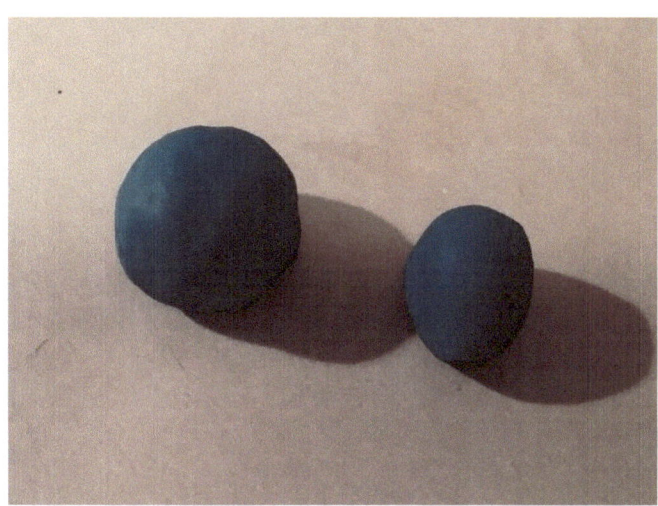

Instructions:

1. Get a golf ball sized piece of play-doh.
2. Put it between your palms.
3. Squeeze it into as close to a ball shape as you can.
4. Lay the ball on the table and roll it between your palm and table, making it into a ball.
5. Next, get a piece of play-doh between ¼ and ½ the size of your ball.
6. Give it to your child to make a ball.
7. Model how to make a ball again if you need to.

Accompanying activity: *August #1*
Go to the toy store to see how many different sized balls you can find.

Accompanying website: *August #1*
Website: Hyakusho
On this website, there are photographs of polished clay balls. There are also a couple of very quick videos that show how to form and polish the balls.

Two-year-old curriculum

Unit #8: Mixed up miscellaneous
August: Activity #2 - Introduction to sculpture -Making a turtle

FOCUS:
Creating a sculpture by manipulating the shape of Play-doh

MATERIALS:
Play-doh
hands

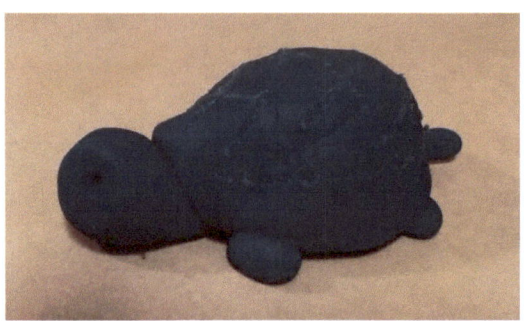

Instructions:

Using the skills just you just learned to make a ball, you will create a turtle.

1. Make five pea sized balls by rolling out the play-doh.
2. These will be the turtle's feet and tail.
3. Make one grape sized ball by rolling out the play-doh.
4. This will be the turtle's head.
5. Make one even larger ball, about the size of a jumbo pasta shell, for the turtle's body and shell.
6. Estimate where to put the smaller balls for the feet and tail by laying the body on a surface such as a table.
7. Place the feet and tail on the surface after you have estimated.
8. Help your child place the body on top of the feet and tail and press down so the body sticks to the feet and tail.
9. Turn the turtle upside down to attach the head to the front side of the body by gently pressing the head onto the body.

*Optional:
If you like, you can use a pencil to scratch a design into the turtle's shell.

Accompanying activity: *August #2*
Go to the pond on a sunny day. See how many turtles you can count.

Two-year-old curriculum

Unit #8: Mixed up miscellaneous
August: Activity #3 - Obleck - introduction to texture

FOCUS:
Introduction to texture by touch

MATERIALS:
measuring cup
one cup cornstarch
½ cup water
disposable aluminum pan
food color
coins

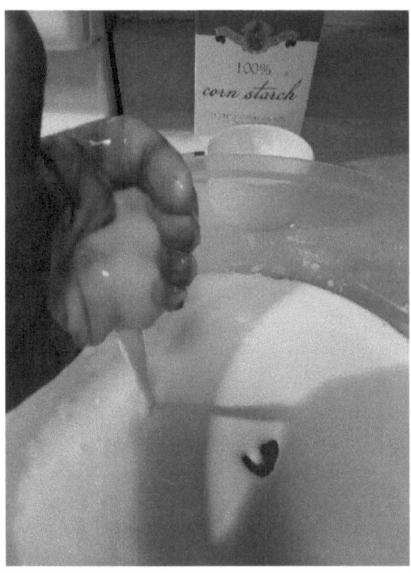

Instructions:

1. Put the cornstarch in the pan.
2. Add a drop or two of food color.
3. Slowly pour the water into the pan, mixing slowly with the cornstarch.
4. Once the water and cornstarch are mixed, you are ready to experiment with its texture.
5. Have your child feel it, try to pick it up, try to mix it.

Optional:
- Drop a coin into the mixture and watch it sink.
- Try to get it out.

Accompanying activity: *August #3*
Look for textures in your house and outside that feel different. Try a cotton ball, the rug, the table, the concrete. Is it soft? Is it rough or smooth?

Two-year-old curriculum

Unit #8: Mixed up miscellaneous
August: Activity #4 - Bubble paint design

FOCUS:
Creating a design from
Bubbles

MATERIALS:
white construction paper
bubbles for blowing
food coloring

Instructions:

1. Lay out the sheet of paper.
2. Place a tablespoon of food color into the bubble bottle.
3. Gently turn the bottle upside down and right side up several times to mix the color.
4. Do this slowly so it won't turn into foam.
5. Have your child blow bubbles through the wand onto the paper.
6. As the bubbles pop, interesting designs are made.

Accompanying activity: *August July #4*
Go outside and blow bubbles. Watch the wind carry them away!

Accompanying video: *August #4*
Video: This bubble artists amazing bubble skills will blow you away.
This video is fantastic! It shows some amazing things that can be done with bubbles. Both you and your child will be amazed!

Two-year-old curriculum

Unit #8: Mixed up miscellaneous
August: Activity #5 – Dot marker pattern

FOCUS:
Reinforcing Primary colors

MATERIALS:
white construction paper
red dot marker
blue dot marker
yellow dot marker

Instructions:

1. Lay out the sheet of paper.
2. Remind your child of when you used dot markers.
3. Remind your child that red, blue and yellow are Primary colors.
4. Show your child how to make a pattern and tell your child you are making a pattern by dotting the page with red first, blue second and yellow third.
5. Repeat your pattern.
6. Give your child the dot markers and ask your child to make a pattern.
7. Allow your child to come up with his/ her own pattern.

Accompanying activity: *August #5*
Notice patterns in the environment. Perhaps a restaurant has a checkered tablecloth. Maybe you are wearing a shirt with stripes.

Two-year-old curriculum

Unit #8: Mixed up miscellaneous
August: Activity #6 - dot marker pattern

FOCUS:
Reinforcing Secondary colors
Reinforcing Secondary colors

MATERIALS:
white construction paper
green dot marker
orange dot marker
purple dot marker

Instructions:

1. Lay out the sheet of paper.
2. Remind your child of when you used dot markers.
3. Remind your child that green, orange and purple are Secondary colors.
4. Show your child how to make a pattern.
5. Tell your child you are making a pattern by dotting the page with green first, orange second and purple third.
6. Repeat your pattern.
7. Give your child the bingo markers and ask your child to make a pattern.
8. Allow your child to come up with his/ her own pattern.

Accompanying website: *August #6*
Work to view: See the website of Julia Rothman Illustration and pattern.

Two-year-old Curriculum

Unit #8: Mixed up miscellaneous
August: Activity #7 – Stringing beads

FOCUS:
stringing beads

MATERIALS:
large pony beads
plastic elastic string
scissors

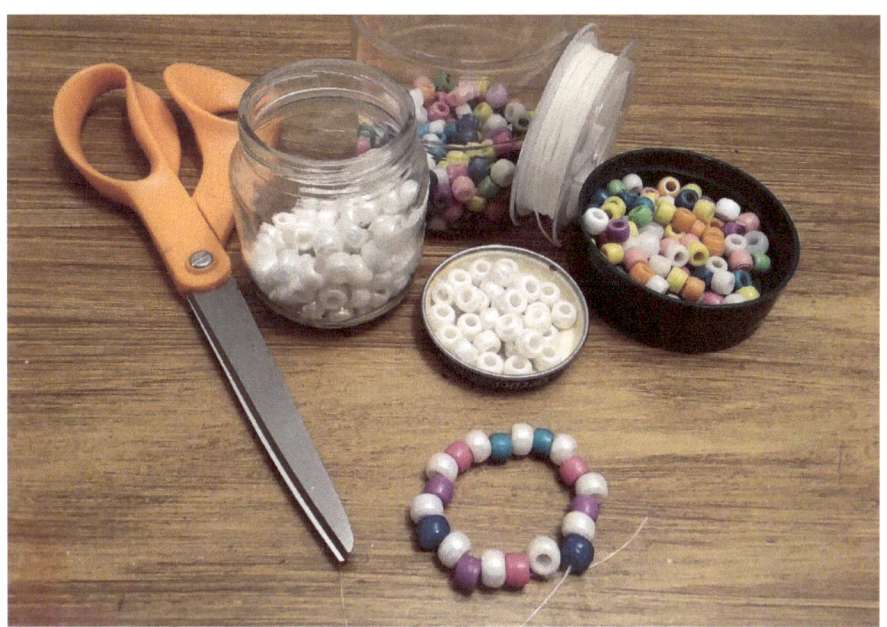

Instructions:

1. When the first bead is strung, tie the string around it so it doesn't fall off.
2. Cut a piece of elastic band.
3. Lay pony beads on the table.
4. Show your child how to put the beads onto the string.
5. Give your child some beads and string and allow your child to string some beads.
6. When the string is large enough to go around the child's wrist, cut and tie it to make a bracelet.

Accompanying activity: *August #7*
Notice the beaded jewelry at your local art fair.

Two-year-old Curriculum

Unit #8: Mixed up miscellaneous
August: Activity #8 – Making a pattern with beads

FOCUS:
patterning with beads

MATERIALS:
large pony beads in two colors
plastic elastic string
scissors

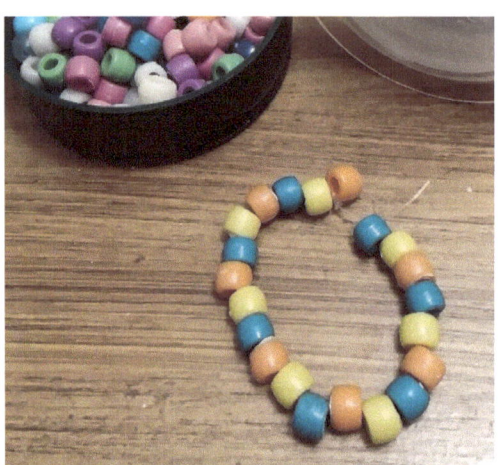

Instructions:

1. Cut a piece of elastic band.
2. Lay the pony beads on the table.
3. String the first bead onto the elastic.
4. When the first bead is strung, tie the string around it so it doesn't fall off.
5. Next, show your child how to make a pattern by putting the beads onto the string with one color then the other.
6. Repeat the colors.
7. Give your child some beads and the string and allow your child to string a pattern.
8. When the string is large enough to go around the child's wrist, cut and tie it to make a bracelet.

Accompanying video: *August #8*
Video: KCL The art of making glass beads for jewelry.
This video shows how to fire the actual beads for jewelry making.

Two-year-old curriculum

UNIT #9

Unit nine Introduction and explanation:

Unit nine of The Two-year-old curriculum and activity book reintroduces and reinforces the shapes and colors learned in Units One and Two. Here, printmaking will be explored using the Primary colors red, blue and yellow, along with the shape, circle. The Secondary colors green, orange and purple will also be reintroduced and reinforced as you create more prints! In this unit you will be using a simple circle shapes along with a variety of cookie cutters.

As you play through this unit with your child, encourage him/her to repeat the vocabulary words as you talk about each activity.

Vocabulary:

Primary colors	Secondary colors
red	green
blue	orange
yellow	purple
print	

Learning styles addressed:
Visual
Kinesthetic- fine motor, sensory

Learning Links:
Art- colors: red, blue, yellow
 green, orange, purple
 printmaking

Two-year-old Curriculum

Unit #9: Printmaking
September: Activity #1 – Making red circles

FOCUS:
Printmaking

MATERIALS:
white construction paper
paper plates
red non-toxic paint
Styrofoam cup

Instructions:

1. Lay out the sheet of paper.
2. Place a large enough drop of red paint onto the paper plate to be the width of the cup.
3. Dip the top of the cup into the red paint.
4. Then, place the cup onto the paper to make circles.
5. The circles can be in a row or overlap.

Accompanying activity: *September #1*
Notice things in the environment that are red. A stop sign is red. What else can you see that's red?

Two-year-old Curriculum

Unit #9: Printmaking
September: Activity #2 - Making blue circles

FOCUS:
Printmaking

MATERIALS:
white construction paper
paper plates
blue non-toxic paint
plastic cups

Instructions:

1. Lay out the sheet of paper.
2. Place a large enough drop of blue paint onto a paper plate to be the width of the cup.
3. Dip the top of the cup into the blue paint.
4. Then, place the cup onto the paper to make circles.
 The circles can be in a row or overlap.

Accompanying activity: *September #2*
Notice things in the environment that are blue. Maybe you can look for blue cars on a trip to the grocery store. Where else can you find something blue?

Two-year-old Curriculum

Unit #9: Printmaking
September: Activity #3 - Making yellow circles

FOCUS:
Printmaking

MATERIALS:
white construction paper
paper plates
yellow non-toxic paint
Styrofoam cup

Instructions:

1. Lay out the sheet of paper.
2. Place a large enough drop of yellow paint onto the paper plate so that it is the width of the cup.
3. Dip the top of the cup into the yellow paint.
4. Then, place the cup onto the paper to make circles.
 The circles can be in a row or overlap

Accompanying activity: *September #3*
Notice things in the environment that are yellow. The McDonald's arches are yellow. What else can you find that's yellow?

Two-year-old Curriculum

Unit #9: Printmaking
September: Activity #4 – Making circles with Primary colors

FOCUS:
Colors: red, blue, yellow
Shape: circle

MATERIALS:
white construction paper
paper plates
non-toxic red paint
non-toxic blue paint
non-toxic yellow paint
plastic cups

Instructions:

1. Lay out the sheet of paper.
2. Place a large drop of red paint onto a paper plate.
3. Place a large drop of blue paint onto a paper plate.
4. Place a large drop of yellow paint onto a paper plate.
5. Dip one cup into the red paint and make a circle on the paper.
6. Dip one cup into the blue paint and make a circle on the paper.
7. Dip one cup into the yellow paint and make a circle on the paper.
8. Repeat until you have the look you want.
 * This activity reinforces the Primary colors.

Accompanying activity: *September #4*
Notice things in the environment that are red. A stop sign is red. What else can you see that's red?

Accompanying activity: *September #4*
Notice things in the environment that are blue. Maybe you can look for blue cars on a trip to the grocery store. Where else can you find something blue?

Accompanying activity: *September #4*
Notice things in the environment that are yellow. The McDonald's arches are yellow. What else can you find that's yellow?

Two-year-old Curriculum

Unit #9: Printmaking
September: Activity# 5 - Making Lego prints

FOCUS:
printmaking
red
blue
yellow
dots

MATERIALS:
white construction paper
paper plates
red non-toxic paint
blue non-toxic paint
yellow non-toxic paint
Legos

Instructions:

1. Lay out the sheet of paper.
2. Place a large drop of red paint onto a paper plate.
3. Place a large drop of blue paint onto a paper plate.
4. Place a large drop of yellow paint onto a paper plate.
5. Let your child use a separate Lego for each color of paint (dip circular side into paint).
6. Allow your child to dip one Lego into the red paint. Then, press the circular side of the Legos onto the paper to make Lego prints.
7. Allow your child to dip one Lego into the blue paint.
8. Then, press the circular side of the Lego onto the paper to make Lego prints.
9. Allow your child to dip one Lego into the yellow paint.
10. Then, press the circular side of the Lego onto the paper to make Lego prints.

This activity can also be used to reinforce patterns by using one color and then the next in a sequence.

Accompanying activity: *September #5*
Build something with your Legos. As you are building name the colors of the Legos you are using. Notice the small circles on the Legos.

Two-year-old Curriculum

Unit #9: Printmaking
September: Activity #6 – Printmaking with the Secondary color green

FOCUS:
Printmaking
green

MATERIALS:
white construction paper
paper plates
green non-toxic paint
cookie cutters (assorted plastic)

Instructions:

1. Lay out the sheet of paper.
2. Place a large drop of green paint onto a paper plate.
3. Have your child dip a cookie cutter into the green paint.
4. Then, have your child place the cookie cutter shape onto the paper to make cookie cutter prints.

*This is a fun project for any time of year. You can use holiday shapes around the holidays.

Accompanying activity: *September #6*
Look for things in the environment that are green. The leaves on the trees are green. The grass is green. What else can you find that's green?

Two-year-old Curriculum

Unit #9: Printmaking
September: Activity# 7 - Printmaking using the Secondary color orange

FOCUS:
Printmaking
orange

MATERIALS:
white construction paper
paper plates
orange non-toxic paint
cookie cutters

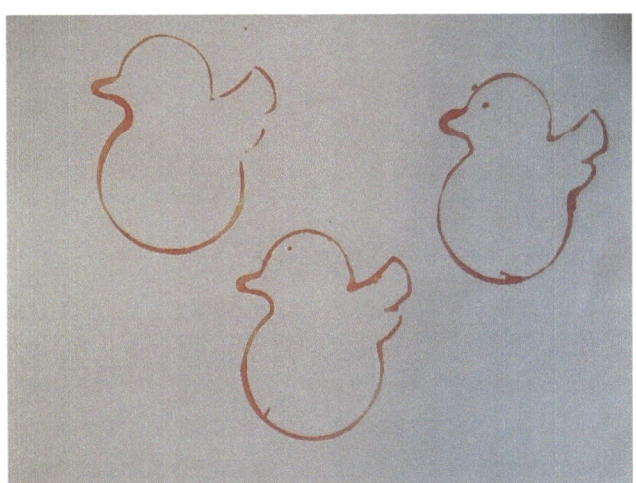

Instructions:

1. Lay out the large white paper.
2. Place a large drop of orange paint onto a paper plate.
3. Have your child dip a cookie cutter into the orange paint.
4. Then, have your child place the cookie cutter shape onto the paper to make prints.

*This is a fun project for any time of year. You can use holiday shapes around the holidays.

Accompanying activity: *September #7*
What can you find that is orange? Halloween is coming. Do you see Pumpkins and Jack-o-lanterns in the stores?

Two-year-old Curriculum

Unit #9: Printmaking:
September: Activity # 8 – Printmaking using the Secondary color purple

FOCUS:
Printmaking
purple

MATERIALS:
white construction paper
paper plates
purple non-toxic paint
cookie cutters

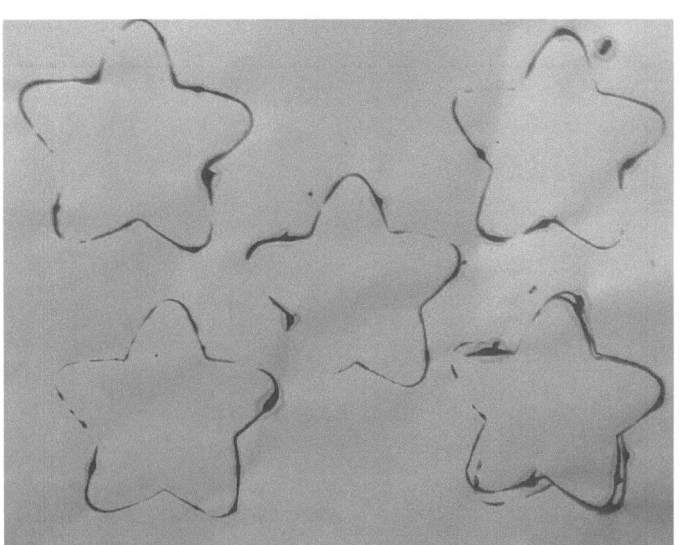

Instructions:

1. Lay out the large white paper.
2. Place a large drop of purple paint onto a paper plate.
3. Have your child dip a cookie cutter into the purple paint.
4. Then, have your child place the cookie cutter shape onto the paper to make prints.

*This is a fun project for any time of year. You can use holiday shapes around the holidays.

Accompanying activity: *September #8*
What do you see that is purple? While you are out shopping perhaps you can find some purple socks, or maybe a purple ball.

Two-year-old Curriculum

Unit #9: Printmaking
October: Activity #1-Secondary color prints

FOCUS:
Printmaking
Secondary colors:
green
orange
purple

MATERIALS:
white construction paper
paper plates
green non-toxic paint
orange non-toxic paint
purple non-toxic paint
cookie cutters

Instructions:

1. Lay out the large white paper.
2. Place a large drop of green paint onto a paper plate.
3. Place a large drop of orange paint onto a paper plate.
4. Place a large drop of purple paint onto a paper plate.
5. Let your child use a separate cookie cutter for each color of paint.
6. Dip one cookie cutter into green.
7. Place the cookie cutter onto the paper to make prints.
8. Dip one cookie cutter into orange.
9. Place the cookie cutter onto the paper to make prints.
10. Dip one cookie cutter into purple.
11. Place the cookie cutter onto the paper to make prints.
12. Repeat over and over again until you have a beautiful print work!

Accompanying activities are listed on the following page.

Accompanying activity: *October #1*
Look for things in the environment that are green. The leaves on the trees are green. The grass is green. What else can you find that's green?

Accompanying activity: *October #1*
What can you find that is orange? Halloween is coming. Do you see Pumpkins and Jack-o-lanterns in the stores?

Accompanying activity: *October #1*
What do you see that is purple? While you are out shopping perhaps you can find some purple socks, or maybe a purple ball.

Accompanying activity: *October #1*
Look for things in the environment that are green. The leaves on the trees are green. The grass is green. What else can you find that's green?

Accompanying activity: *October #1*
What can you find that is orange? Halloween is coming. Do you see Pumpkins and Jack-o-lanterns in the stores?

Two-year-old Curriculum

Unit #9: Printmaking
October: Activity #2 – Printmaking with the Secondary colors

FOCUS:
Printmaking
Secondary colors:
green
orange
purple

MATERIALS:
white construction paper
paper plates
green non-toxic paint
orange non-toxic paint
purple non-toxic paint
Legos

Instructions:

1. Lay out the large white paper.
2. Place a large drop of green paint onto a paper plate.
3. Place a large drop of orange paint onto a paper plate.
4. Place a large drop of purple paint onto a paper plate.
5. Dip the side of the Lego with the circles into the paint.
6. Have your child dip one Lego into the green paint.
7. Place the Lego on the paper to make prints.
8. Have your child dip one Lego into orange.
9. Place the Lego on the paper to make prints.
10. Have your child dip one Lego into purple.
11. Place the Lego on the paper to make prints.

Accompanying activity: *October #2*
Build something with your Legos. As you are building name the colors of the Legos you are using. Notice the small circles on the Legos.

Two-year-old Curriculum

Unit #9: Printmaking
October: Activity #3 – Printmaking with fruit

FOCUS:
Printmaking
red

MATERIALS:
white construction paper
paper plate
red non-toxic paint
apple
knife
fork

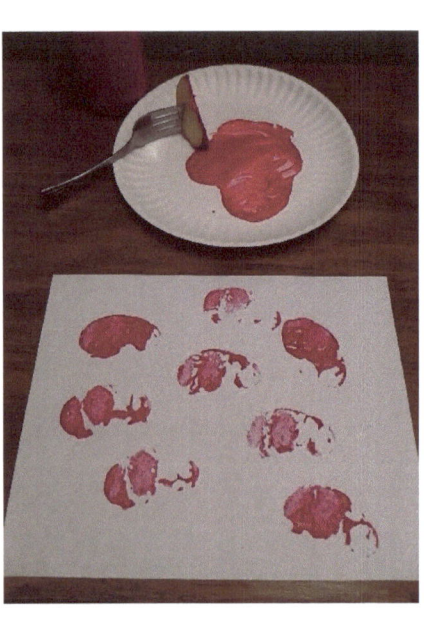

Instructions:

1. Lay out the large white paper.
2. Place a large drop of red paint onto the paper plate.
3. Slice the apple in half. (Be sure your child is a safe distance from the knife to avoid getting cut.)
4. Stick the fork in the outside half of the apple and use it as a handle.
5. Have your child dip the apple into the red paint.
6. Have your child press the apple onto the paper to make apple prints.

(Be sure your child knows you cannot eat this apple.)

Accompanying activity: *October #3*
Go on a trip to the apple orchard. Pick some apples to take home to eat.

Two-year-old Curriculum

Unit #9: Printmaking
October: Activity #4 – Printmaking with block prints

FOCUS:
Printmaking

MATERIALS:
white construction paper
leaf shaped print blocks
orange, red and yellow large ink pads

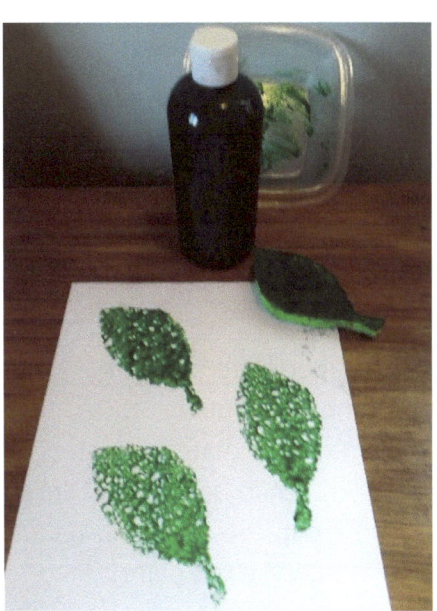

Instructions:

1. Lay out the large white paper.
2. Press a leaf block onto the ink pad.
3. Press the block onto the paper to make fall leaf prints.
4. Repeat.

Accompanying activity: *October #4*
Take a walk outside and notice the changing colors of the leaves.

****substitution:** You can make a block print by cutting out a sponge in the shape of a leaf. Then use either ink or paint to dip the sponge in.

Two-year-old Curriculum

Unit #9: Printmaking
October: Activity #5 – Daytime Pumpkin patch

FOCUS:
Printmaking
red, yellow

MATERIALS:
white construction paper
red non-toxic paint
orange non-toxic paint
yellow non-toxic paint
2 potatoes
Knife
forks

Instructions:

- Lay out the large white paper.
- Place a drop of red paint onto one paper plate.
- Place a drop of orange paint onto one paper plate.
- Place a drop of yellow paint onto one paper plate.
- Slice the potatoes in half. (Be sure your child is a safe distance from the knife).
- Stick the forks into the outside of the potatoes to use as handles.
- Have your child dip one potato slice into the red paint.
- Have your child dab the potato onto the paper to make a pumpkin.
- Have your child dip one potato slice into the orange paint.
- Have your child dab the potato onto the paper to make a pumpkin.
- Have your child dip one potato slice into the yellow paint.
- Have your child dab the potato onto the paper to make a pumpkin.
- Experiment using the red and yellow paint, adding some to the orange to create darker and lighter orange hues.
- Have your child put as many pumpkins on the page as he/ she likes to make your pumpkin patch as big as your child likes it!

(*See the following page for directions on mixing hues.*)

*Optional – you can use a green crayon to color grass around your pumpkins when they dry.

Accompanying activity: *October #5*
Take another trip to the orchard to pick out a pumpkin for Halloween.

Two-year-old Curriculum

Mixing Hues

How to mix a lighter orange hue:
- Put some yellow onto a paper plate.
- Slowly add a small amount of orange until you arrive at the desired color.

How to mix a darker orange hue:
- Put some orange onto a paper plate.
- Slowly add a small amount of red until you arrive at the desired color.

Two-year-old Curriculum

Unit #9: Printmaking
October: Activity #6 – Nighttime pumpkin patch

FOCUS:
Printmaking
red
orange
yellow

MATERIALS:
black construction paper
paper plate
red non-toxic paint
orange non-toxic paint
yellow non-toxic pain
potatoes
knife
forks

Instructions:

1. Lay out the large sheet of black paper.
2. Place drops of red, orange and yellow paints onto separate paper plates.
3. Slice the potatoes in half. (Be sure your child is a safe distance from the knife to avoid getting cut).
4. Stick the forks into the outside of the potatoes to use as handles.
5. Place one potato slice into the red paint.
6. Have your child dab the potato onto the paper to make a pumpkin.
7. Place one potato slice into the orange paint.
8. Have your child dab the potato onto the paper to make a pumpkin.
9. Place one potato slice into the yellow paint.
10. Have your child dab the potato onto the paper to make a pumpkin.
11. Experiment using the red and yellow paints, adding some to the orange to create darker and lighter orange hues.

(*See mixing hues instructions on the previous page.*)

Accompanying activity: *October #6*
Make your Pumpkin into a Jack-o-lantern and watch it light up at night.

UNIT #10

Two-year-old curriculum

Unit ten Introduction and explanation:

Unit ten of The Two-year-old curriculum and activity book will have you and your child using different types of paper and flowers with different textures. Using fine motor skills, you will rip and cut the paper. During this unit you will also be experimenting with glue, feathers and glitter! There will be several textures to feel.

As you play through this unit with your child, encourage him/her to repeat the vocabulary words as you talk about each activity.

Vocabulary:
Glue
Tissue paper
Feathers
flowers
glitter

Learning styles addressed:
Visual
Kinesthetic- fine motor, sensory

Learning Links:
Art- texture

Sociology and History – Holidays: Thanksgiving, Christmas

Science – using flowers

Two-year-old Curriculum

Unit #10: Collage
October: Activity #7 – Creating a tree from torn construction paper

FOCUS:
Collage
Manipulating materials by tearing

MATERIALS:
blue construction paper
red, orange, yellow & brown construction paper
scissors
glue

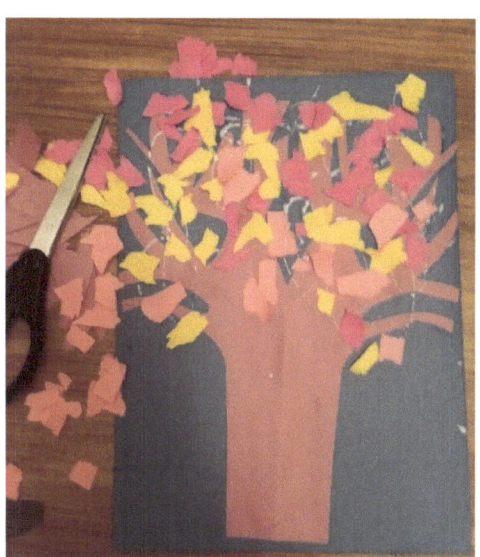

Instructions:

1. Lay out the sheet of blue paper.
2. Cut or tear a tree trunk from the brown construction paper.
3. Glue the trunk to the blue paper.
4. Allow your child to tear and rip pieces of the red, orange and yellow construction paper to make fall leaves.
5. Put some glue onto and around the top of the tree.
6. Have your child glue the red, orange and yellow torn construction paper pieces to the top of the trunk to create a fall tree.

Accompanying reading: *October #7*
Read Curious George Plants a tree.

Unit #10: Collage
October: Activity #8 – Making a Jack-O-Lantern

FOCUS:
Collage
orange
black
triangle
Jack-O-Lantern

MATERIALS:
black construction paper
paper plate
orange paint
scissors
glue stick
plastic table cover

Instructions:

1. Lay out the plastic table cover.
2. Lay out the black construction paper.
3. Place a drop of orange paint onto the paper plate.
4. Allow your child to spread the paint all over plate with his/ her fingers.
5. Cut out large and small triangles from the black construction paper.
6. Once the orange paint is dry, place some glue onto the black triangles.
7. Allow your child to put the triangles on the plate to make a Jack-O-Lantern face.

Accompanying activity: *October #8*
Light up your Jack-o-Lantern by placing a battery-operated candle or light inside it.

Two-year-old Curriculum

Unit #10: Collage
November: Activity #1 – Creating a fall wreath

FOCUS:
Collage, Gluing

MATERIALS:
found, bought or colored cut out leaves
brown paper bag
pencil
scissors
glue
glitter
plate for tracing
bowl for tracing

Instructions:

1. Lay out the paper bag.
2. Draw a large circle on the brown paper bag by tracing the plate.
3. Draw a smaller circle inside the large circle by tracing the bowl.
4. Cut both circles out.
5. If making leaves from construction paper, cut out your leaves.
6. Put some glue on the paper bag circle.
7. Allow your child to place the leaves on the cut-out wreath made from the paper bag.
8. Glue the leaves into place.
9. Place drops of glue on top of the leaves.
10. Sprinkle some glitter on top of the leaves to make your decorative fall wreath.

Accompanying activity: *November #1*
Go for a nature walk ahead of time to collect colorful leaves.

Unit #10: Collage
November: Activity #2 – Dried flower collage

FOCUS:
Collage

MATERIALS:
white, tan or beige construction paper
dried flower petals from garden or nature walk
mums, marigolds, roses, dried leaves
or cut out flower petals from construction paper
paint brush
glue
water

Instructions:

1. Lay out the sheet of paper.
2. Pull apart the dried flowers.
3. Mix glue and water - 1-part glue to 1-part water.
4. Assist your child with spreading the glue mixture onto the paper with the paintbrush.
5. Have your child sprinkle the dried flowers onto the paper to create a dried flower collage.
6. If desired, add a little glitter.

Accompanying activity: *November #2*
Go for a nature walk ahead of time to collect colorful leaves.

Two-year-old Curriculum

Unit #10: Collage
November: Activity #3 – collage

FOCUS:
Collage
Gluing feathers

MATERIALS:
white construction paper
brown construction paper
pencil
scissors
glue
small googly eyes
assorted feathers

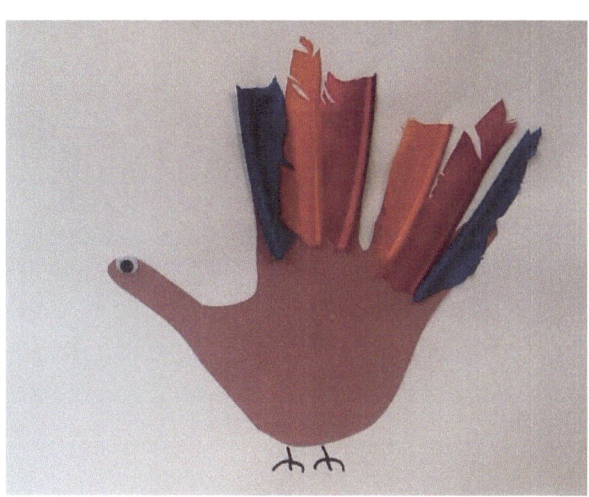

Instructions:

1. Lay out the white sheet of paper.
2. Place your child's hand onto the brown construction paper and trace around it with the pencil.
3. Cut out your child's turkey shaped handprint.
4. Assist your child in gluing the turkey handprint to the white paper.
5. Help your child put some glue on the turkey.
6. Allow your child to decorate the turkey by gluing on feathers to make tail feathers.
7. Place a googly eye onto the thumbprint so your Turkey can see!

Accompanying reading: *November #3*
Read: Twas the day after Thanksgiving: a lift-the-flap story.

Two-year-old Curriculum

Unit #10: Collage
November: Activity #4 – Collage headband

FOCUS:
collage
gluing feathers

MATERIALS:
brown construction paper
scissors
glue
assorted feathers
tape
tape measure (optional)

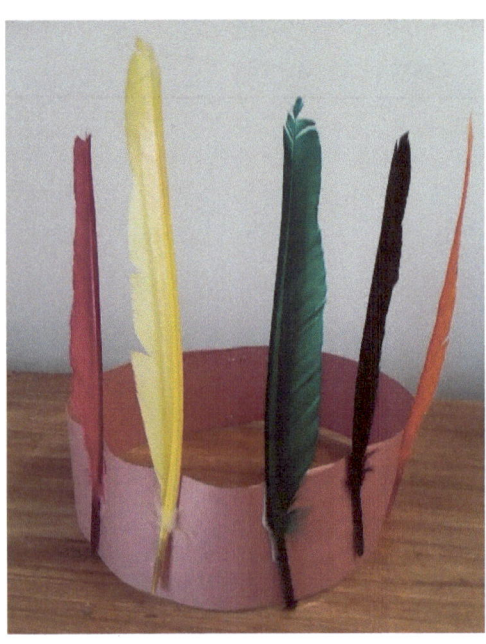

Instructions:

1. Decide on the length of the headband by measuring your child's head.
2. Cut out the desired length from two pieces of construction paper.
3. Tape the pieces of construction paper together.
4. Wrap the headband around your child's head and measure it to fit.
5. Once the fit is right, cut the headband length to fit.
6. Lay the headband on a flat surface.
7. Allow your child to glue feathers to the headband to decorate it.
8. Once dry, tape the headband to fit snuggly around your child's head.

Accompanying website: *November #4*
Google "Native American Headdress" and look at pictures of Native American Headdresses.

Two-year-old Curriculum

Unit #10: Collage
November: Activity #5 – Thanksgiving feast

FOCUS:
Collage
Gluing magazines

MATERIALS:
paper plate
magazines with pictures of food or printed pictures of food
child-safe scissors
glue stick

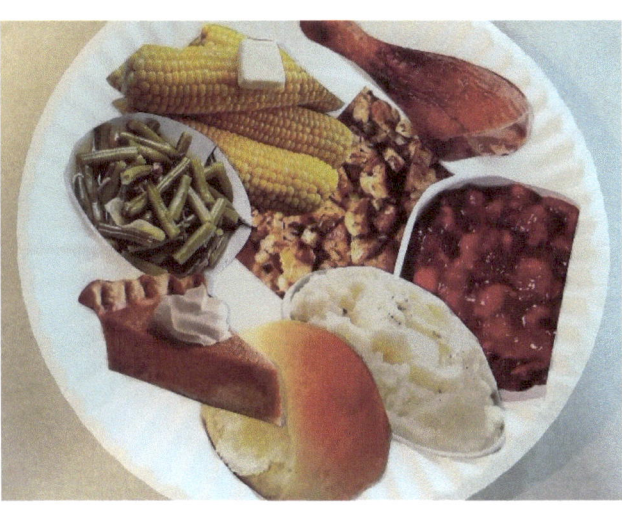

Instructions:

1. Assist your child with cutting out your pictures of food to represent a Thanksgiving feast.
2. Allow your child to put the pictures of food wherever they like them on the paper plate.
3. Assist your child with gluing the pictures on the paper plate to represent your family's Thanksgiving feast.

Accompanying reading: *November #5*
Read: The first Thanksgiving: A lift-flap book.

Two-year-old Curriculum

Unit #10: Collage
November: Activity #6 – Corn on the cob

FOCUS:
Collage
Gluing tissue paper

MATERIALS:
green construction paper
paper plate
scissors
glue
small pieces of yellow tissue paper
green tissue paper

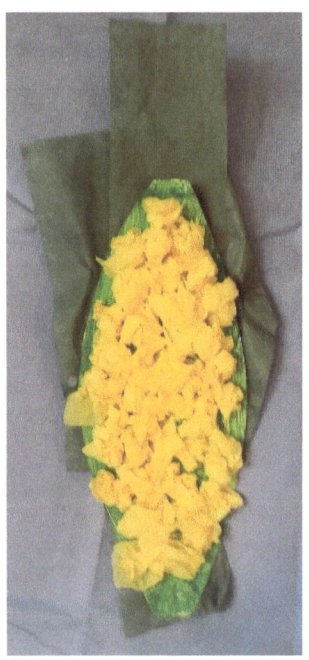

Instructions:

1. Using the scissors, cut out a piece of the paper plate into the shape of an ear of corn.
2. Show your child how to crumble tissue paper into small balls.
3. Pour glue all over the cut-out paper plate.
4. Assist your child in gluing the tissue paper balls onto the plate cutout to make an ear of corn.
5. Cut strips of the green construction paper.
6. Glue some green tissue paper to the top of the corn to look like husks.

Accompanying activity: *November #6*
Make popcorn and eat it! Watch Why does popcorn pop? Science for kids. You Tube.

Two-year-old Curriculum

Unit #10: Collage
November: Activity #7 – Pumpkin pie

FOCUS:

Collage
Gluing paper

MATERIALS:
Paper plate
orange construction paper
brown construction paper
scissors
glue
cotton balls

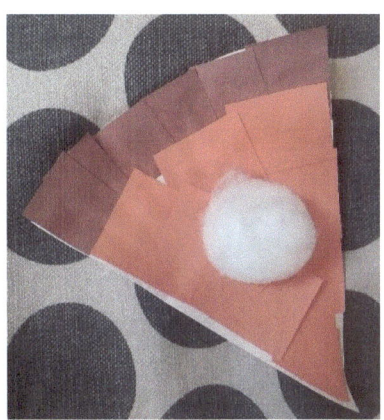

Instructions:

1. Cut out a pie piece shape from the paper plate.
2. Cut out small squares from the brown construction paper.
3. Cut out small squares from the orange construction paper.
4. Put some liquid glue on the pie piece.
5. Assist your child with gluing the brown squares to the curved edge of the pie piece to make the crust.
6. Assist your child with gluing the orange construction paper squares to the paper plate for the pie filling.
7. Assist your child with gluing the two cotton balls on top of the orange construction paper squares for the whipped topping!

Accompanying activity: *November #7*
Treat your tummy and eat a slice of Pumpkin pie.

Two-year-old Curriculum

Unit #10: Collage
November: Activity #8 – Catching a fish for planting

FOCUS:
Collage
Gluing

MATERIALS:
white construction paper
blue construction paper
sheet of gray construction paper *(or color of choice)*
blue marker
liquid glue

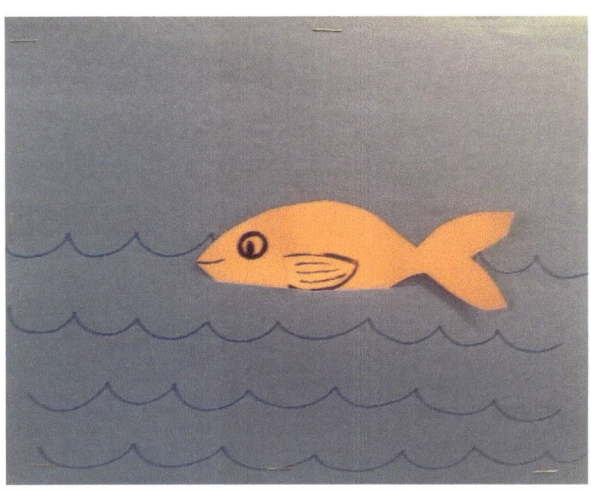

Instructions:

1. Using the scissors, cut a lengthwise horizontal slit in the center of the blue paper.
2. Staple the edges of the blue and white construction paper together, all the way around.
3. Use the fish template to cut out your fish from the gray (or preferred color construction paper).
4. Assist your child in drawing an eye, a mouth and a fin on the side of the fish.
5. Allow your child to use the blue marker to draw waves onto the blue construction paper to make it look like water.
6. Put the fish's head into the water with his tail sticking up.
7. Your child can make the fish go in and out of the water.
8. Can you catch a fish to plant with your corn?

Accompanying reading: *November #8*
Read: Squanto and the First Thanksgiving. This book tells about Squanto and how he taught the pilgrims to grow corn by planting the seeds with a fish.

Fish Template

Two-year-old Curriculum

Unit #10: Collage
December: Activity #1 – Decorating a Christmas tree

FOCUS:
Collage
gluing construction paper

MATERIALS:
green and red construction paper
pencil
scissors
glue
glitter
hole punch
Christmas tree template

Instructions:

1. With the pencil, trace the Christmas tree template onto the green construction paper.
2. Cut out the green Christmas tree.
3. With the hole punch, punch out circles from the red construction paper.
4. Put small drops of glue all over the green Christmas tree.
5. Assist your child with gluing the red circles onto the Christmas tree for ornaments.
6. Sprinkle glitter onto the Christmas tree for added sparkle, if you desire.

Accompanying reading: *December #1*
Read: Touch and Feel Christmas.

Christmas Tree Template

Unit #10: Collage
December: Activity #2 - Mistletoes

FOCUS:
Collage

MATERIALS:
white construction paper
red construction paper
green non-toxic paint
paintbrush
pencil
scissors
glue
red glitter
silver or gold ribbon
hole punch
baby wipes

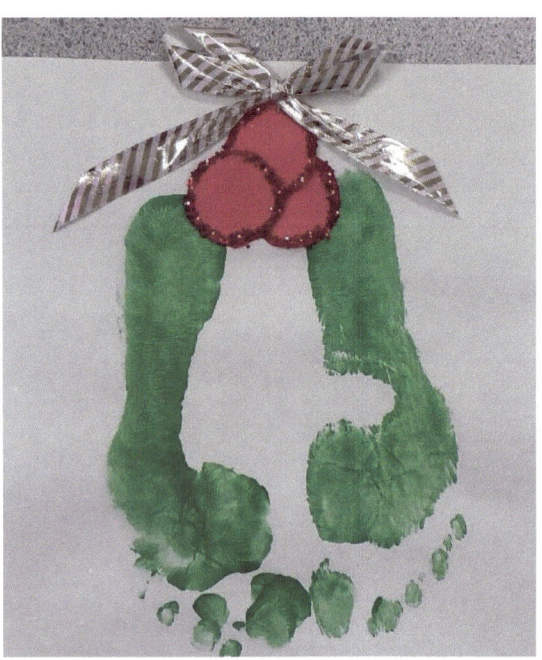

Instructions:

1. Lay out the white paper.
2. Paint the bottom of your child's feet with green paint.
3. Have your child step lightly onto the white paper, leaving footprints.
4. Wipe your child's feet off with the wipes.
5. When the paint is dry, cut out a few small (quarter sized) red circles from the construction paper for berries.
6. Assist your child with gluing the berries to the tops of the heals.
7. Cut out the Mistletoes.
8. Use the hole punch to make a hole at the top of the berries.
9. String the ribbon through the hole and tie a bow.
10. You are ready to hang your mistletoes!

Accompanying activity: *December #2*
Give your child a kiss under the Mistletoe.

Two-year-old Curriculum

Unit #10: Collage
December: Activity #3 – Gingerbread man

FOCUS:
Collage
Gluing

MATERIALS:
brown construction paper
black construction paper
pencil
scissors
glue
hole punch
Gingerbread man pattern (included)

Instructions:

1. Draw a gingerbread man onto the brown construction paper by tracing the enclosed pattern.
2. Cut out the gingerbread man with the scissors.
3. Punch out eleven black circles using the hole punch for the eyes, nose, mouth and buttons.
4. Assist your child with gluing on the black circles in the appropriate places.
5. Glue on two black circles for the eyes.
6. Glue on one black circle for the nose.
7. Glue on six black circles for the mouth.
8. Glue on several black circles for buttons onto the chest of the gingerbread man.

Accompanying activity: *December #3*
Bake Gingerbread cookies and eat them.

Gingerbread Template

Two-year-old Curriculum

Unit #10: Collage
December: Activity #4 – Christmas ornament

FOCUS:
Collage
Gluing glitter

MATERIALS:
poster board
pencil
paint brush
scissors
glue
assorted markers
glitter
hole punch
ribbon
Christmas ornament template

Instructions:

1. Use the pencil to trace the Christmas ornament template onto the poster board.
2. Cut out the ornament.
3. Use the hole punch to punch out a circle in the top of the ornament.
4. Allow your child to color both sides of the ornament with markers making his/her original design.
5. Allow a few minutes for the markers to dry.
6. Put some glue on the paintbrush and assist your child with spreading it over the ornament.
7. Assist your child with sprinkling the ornament with glitter.
8. When the glitter is dry, string the ribbon through the hole and tie it, leaving enough room to hang the ornament on the Christmas tree.

Accompanying activity: *December #4*
Hang your ornament on the Christmas tree.

Ornament Template

Two-year-old Curriculum

Unit #10: Collage
December: Activity #5 – Christmas tree star

FOCUS:
Gluing glitter

MATERIALS:
poster board
yellow non-toxic paint
pencil
paintbrush
scissors
glue
cable tie
gold glitter

Instructions:

1. Using the pencil and the star template, trace the star onto the poster board.
2. Use the scissors to cut out the star.
3. Use the pencil and the rectangle template to draw a rectangle to glue onto back of the star (for attaching to the tree branch).
4. Place some yellow paint on the paper plate.
5. Allow your child to paint the star with the yellow paint.
6. While the paint is still wet, assist your child with sprinkling the gold glitter onto the star.
7. Once the star is dry, attach the rectangle to the star with glue.
8. Let the star dry overnight.
9. Use the cable tie to attach the rectangular part of the star to the Christmas tree.
10. Your child will be pleased that his/her artwork is featured atop your tree!

Accompanying activity: *December #5*
Put the star on your Christmas tree.

Star Template

Two-year-old Curriculum

Unit #10: Collage
December: Activity #6 – Blizzard scene

FOCUS:
Gluing cotton
Gluing glitter

MATERIALS:
blue construction paper
glue
cotton balls
fine silver glitter (*optional)

Instructions:

1. Lay out the blue construction paper.
2. Show your child how to drop glue onto the paper by turning the glue bottle upside down and squeezing.
3. Allow your child to drop dots of glue all over the blue construction paper.
4. Assist your child with pulling the cotton balls apart to make smaller balls or pieces.
5. Help your child glue the cotton pieces to the construction paper.
6. Assist your child with sprinkling glitter all over the cotton to make a sparkly blizzard scene.

Accompanying reading: *December #6*
Read: The Snowy Day by Ezra Jack Keats

Two-year-old Curriculum

Unit #10: Collage
December: Activity #7 – Night time Blizzard

FOCUS:
Gluing cotton
Gluing glitter

MATERIALS:
black construction paper
glue
cotton balls
fine silver glitter (*optional)

Instructions:

1. Lay out the black construction paper.
2. Remind your child of how you placed dots of glue onto the blue paper.
3. Allow your child to place dots of glue all over the black construction paper.
4. Help your child pull the cotton balls apart to make smaller balls or pieces.
5. Assist your child with gluing the cotton pieces onto the construction paper.
6. Assist your child with sprinkling glitter all over the cotton to make a sparkling night time blizzard scene. (*optional)

Accompanying activity: *December #7*
Watch it snow.

Two-year-old Curriculum

Unit #10: Collage
December: Activity #8 – Making a Snowman

FOCUS:
Gluing marshmallows
Gluing glitter

MATERIALS:
blue construction paper
glue
large marshmallows
silver glitter (*optional)

Instructions:

1. Lay out the blue construction paper.
2. Assist your child with gluing 3 marshmallows, one atop another to the construction paper, making a snowman.
3. Allow your child to put some dots of glue all over the paper.
4. Assist your child with sprinkling the paper with silver glitter to create a snowman in the snow. (*optional)

Accompanying reading: *December #8*
Read: Daniel plays in the snow.

The End